STRESS-MELTING FULL-PAGE
PATTERNS

65 DESIGNS FOR ADULTS TO COLOR
Volume 1

Copyright © 2016 by Twin Bulls Media and Daniel Davidson.
All rights reserved. No part of this book may be reproduced in any fashion without written permission from the publisher.

ISBN-13:
978-1537487670

ISBN-10:
1537487671

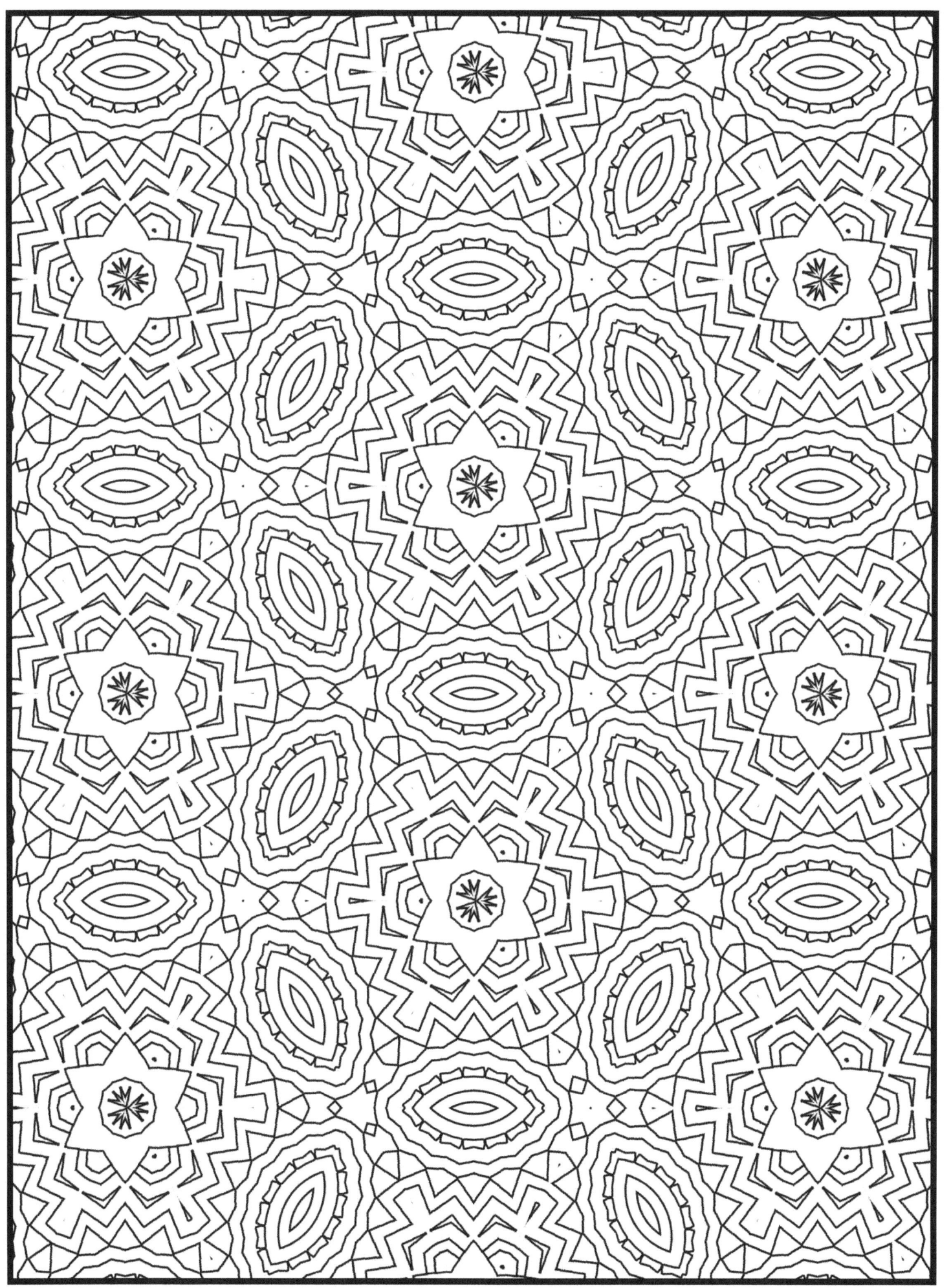

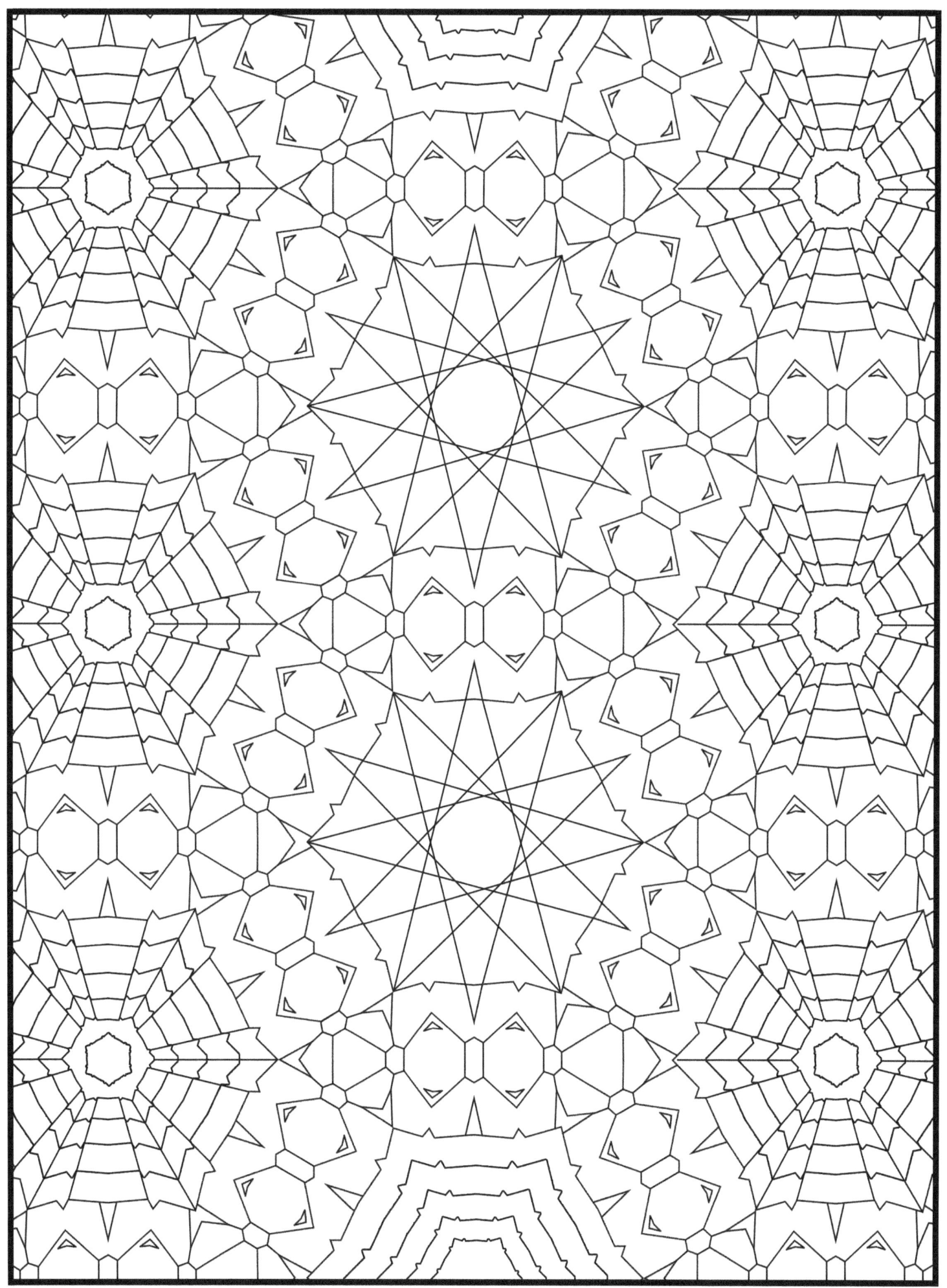

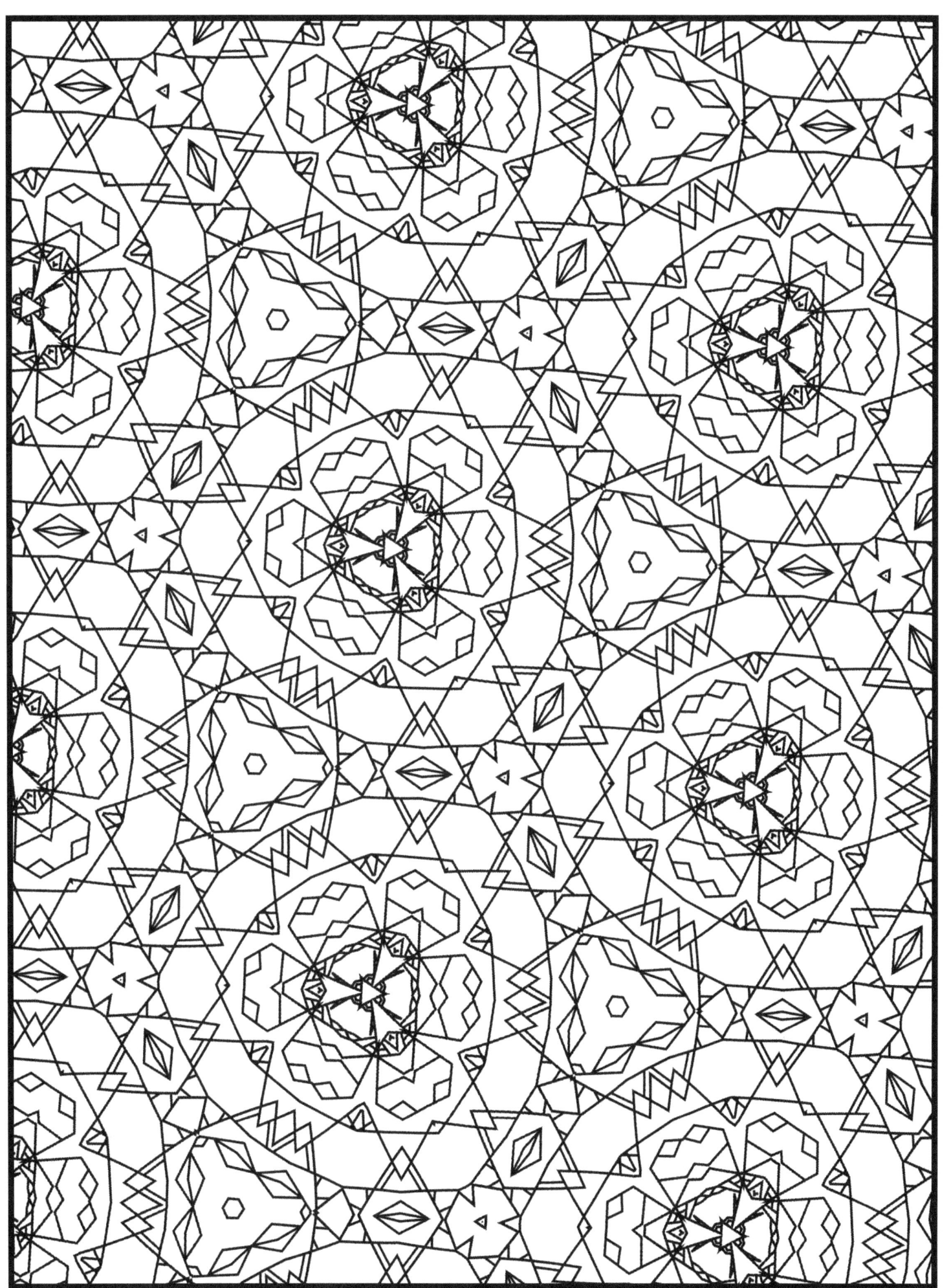

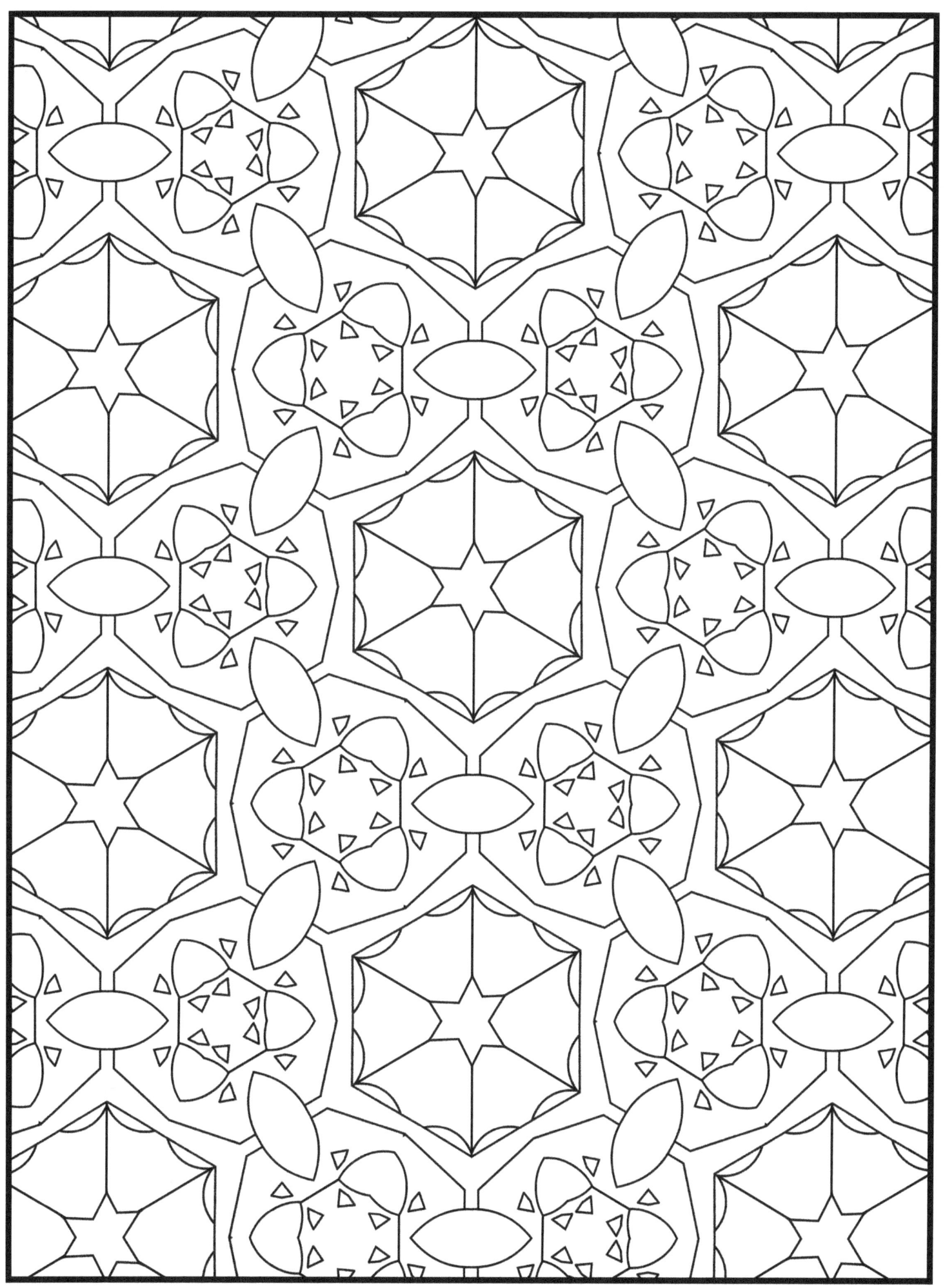

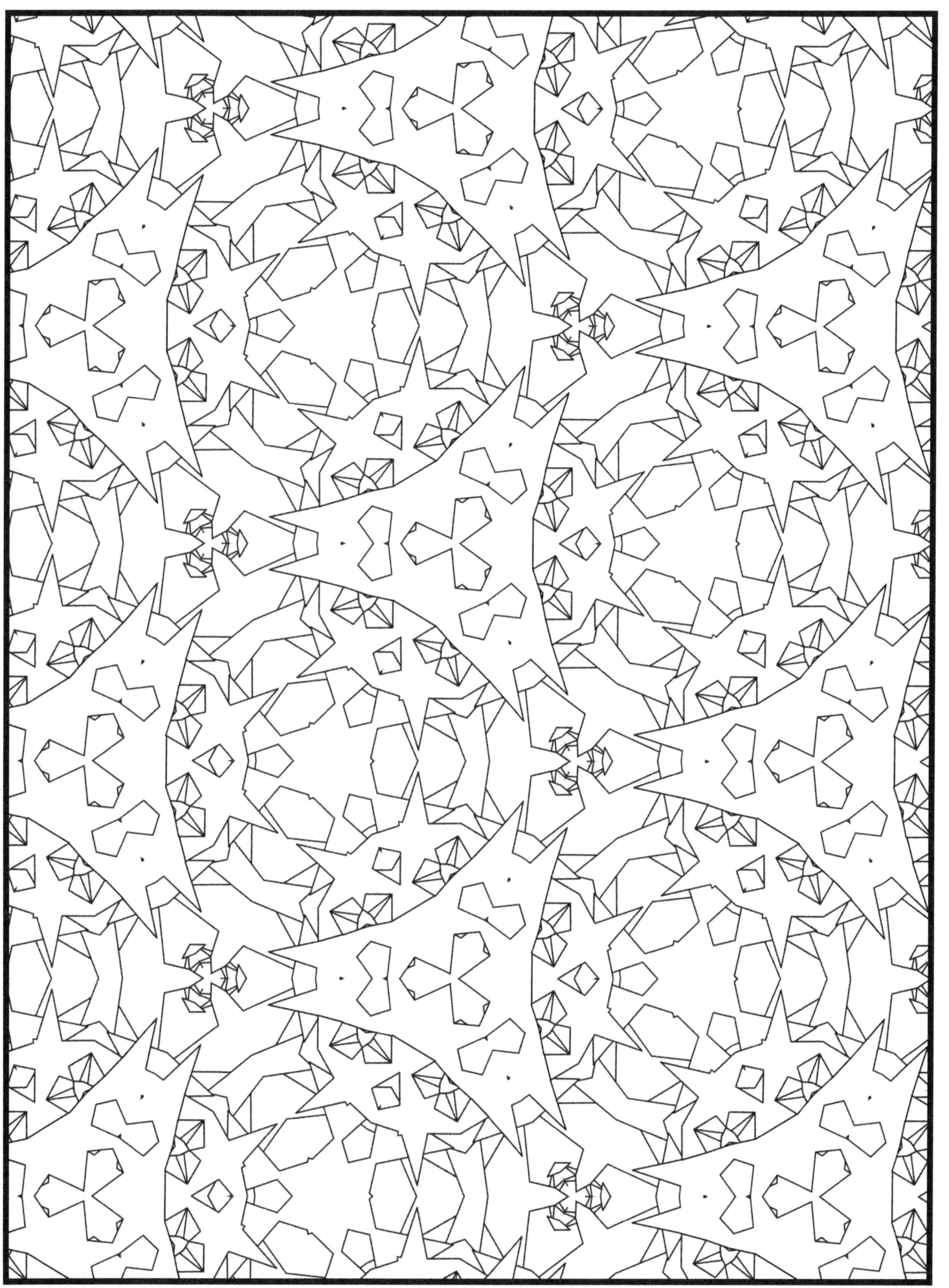

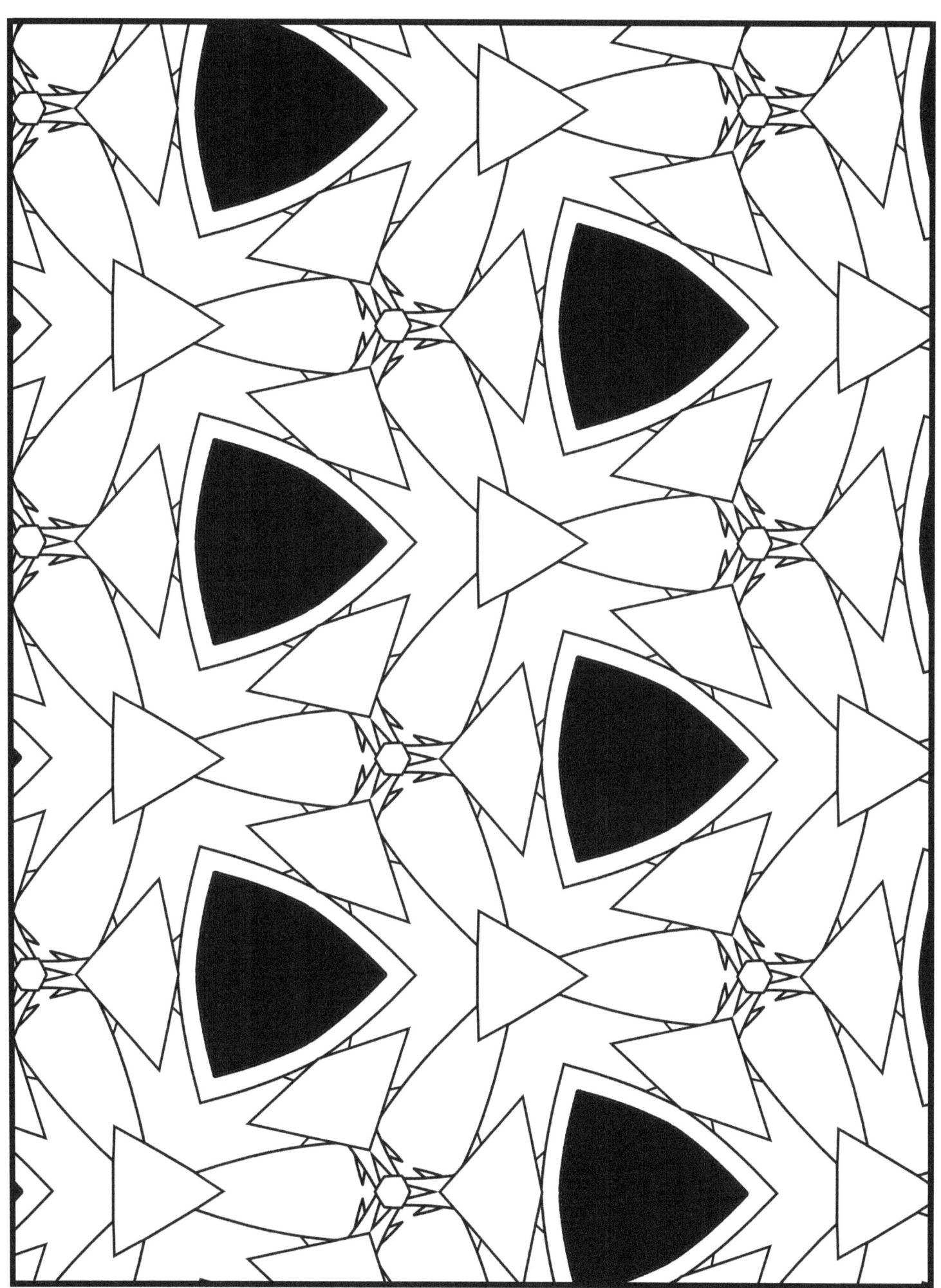

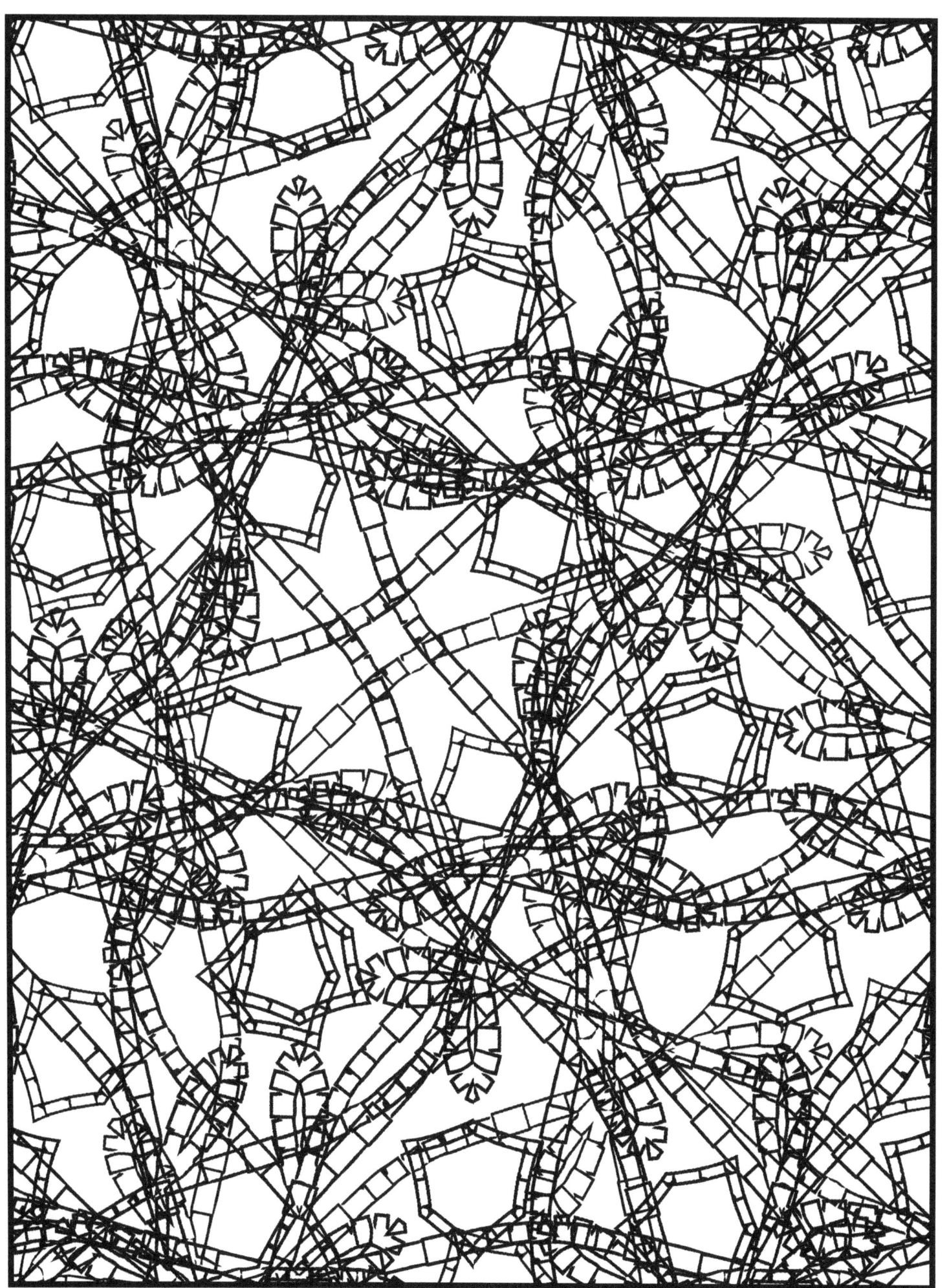

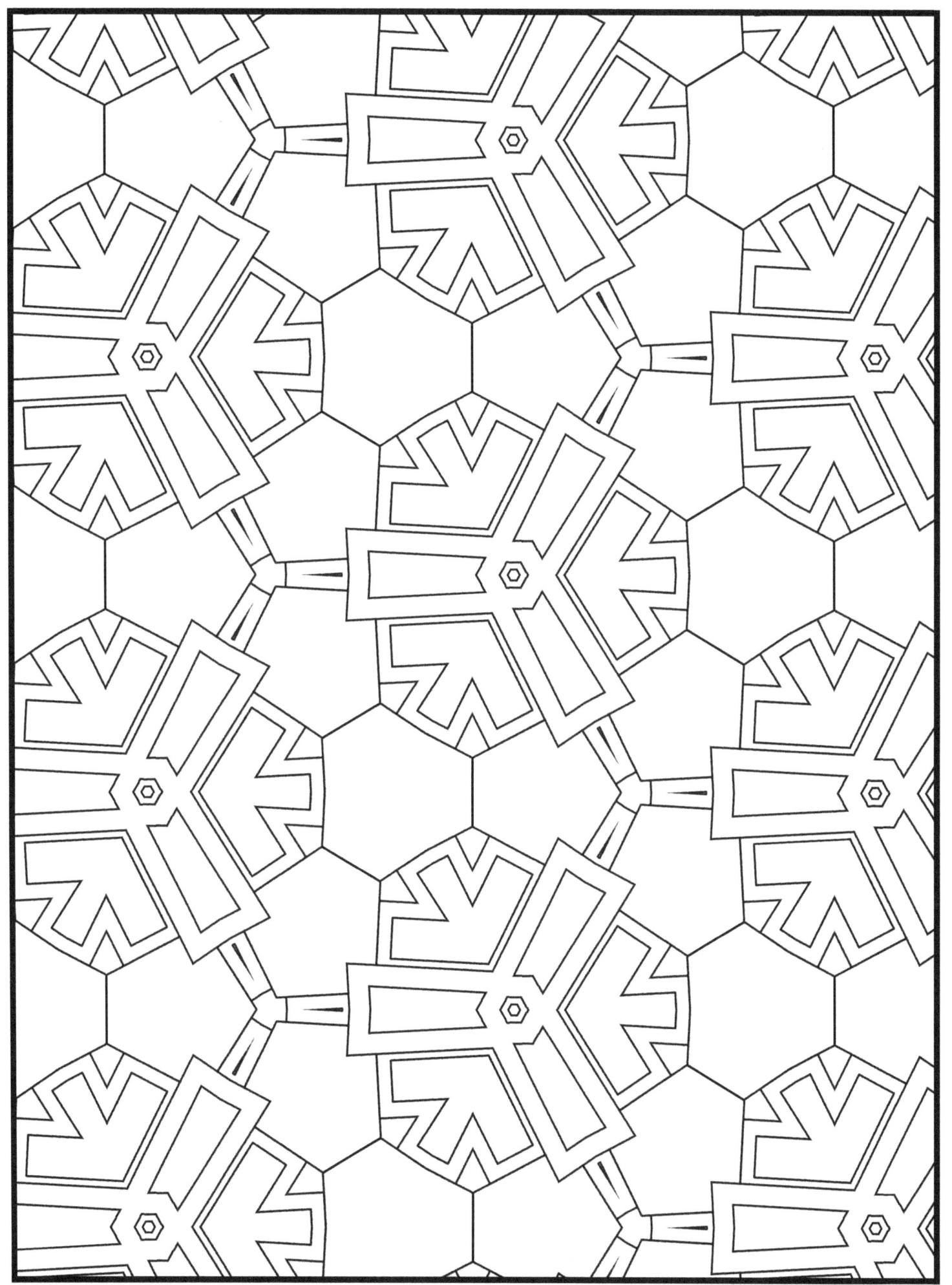

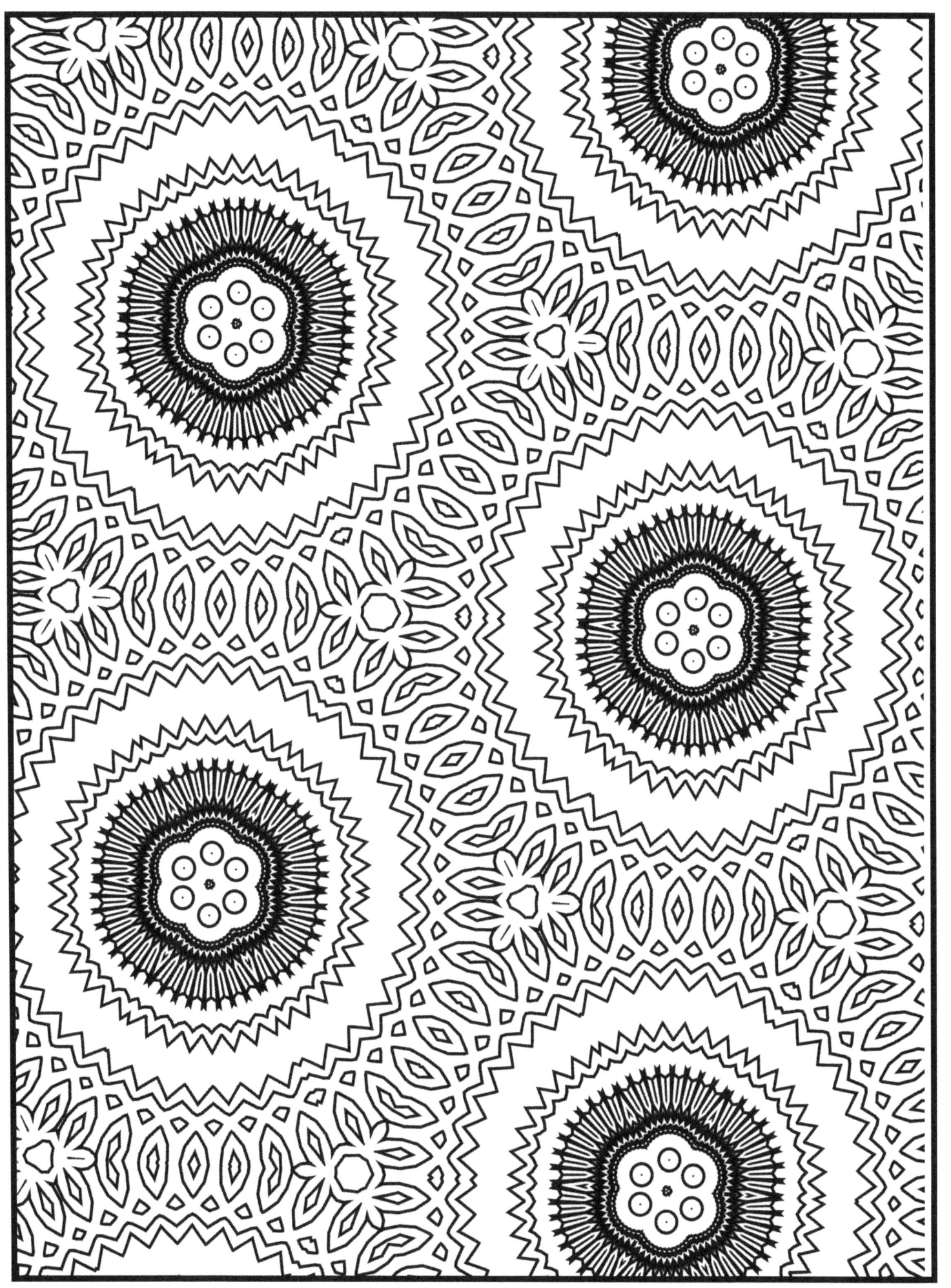

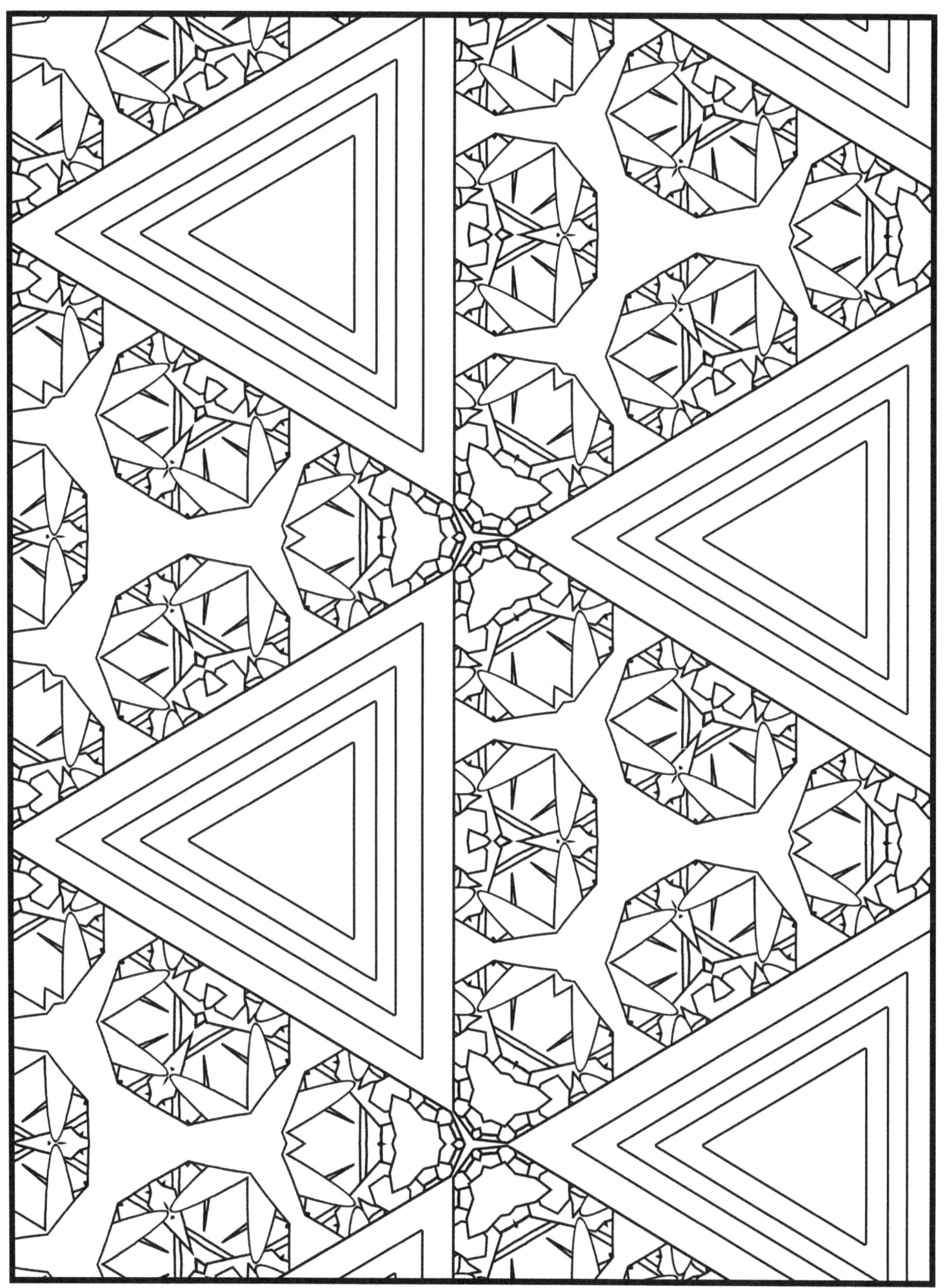

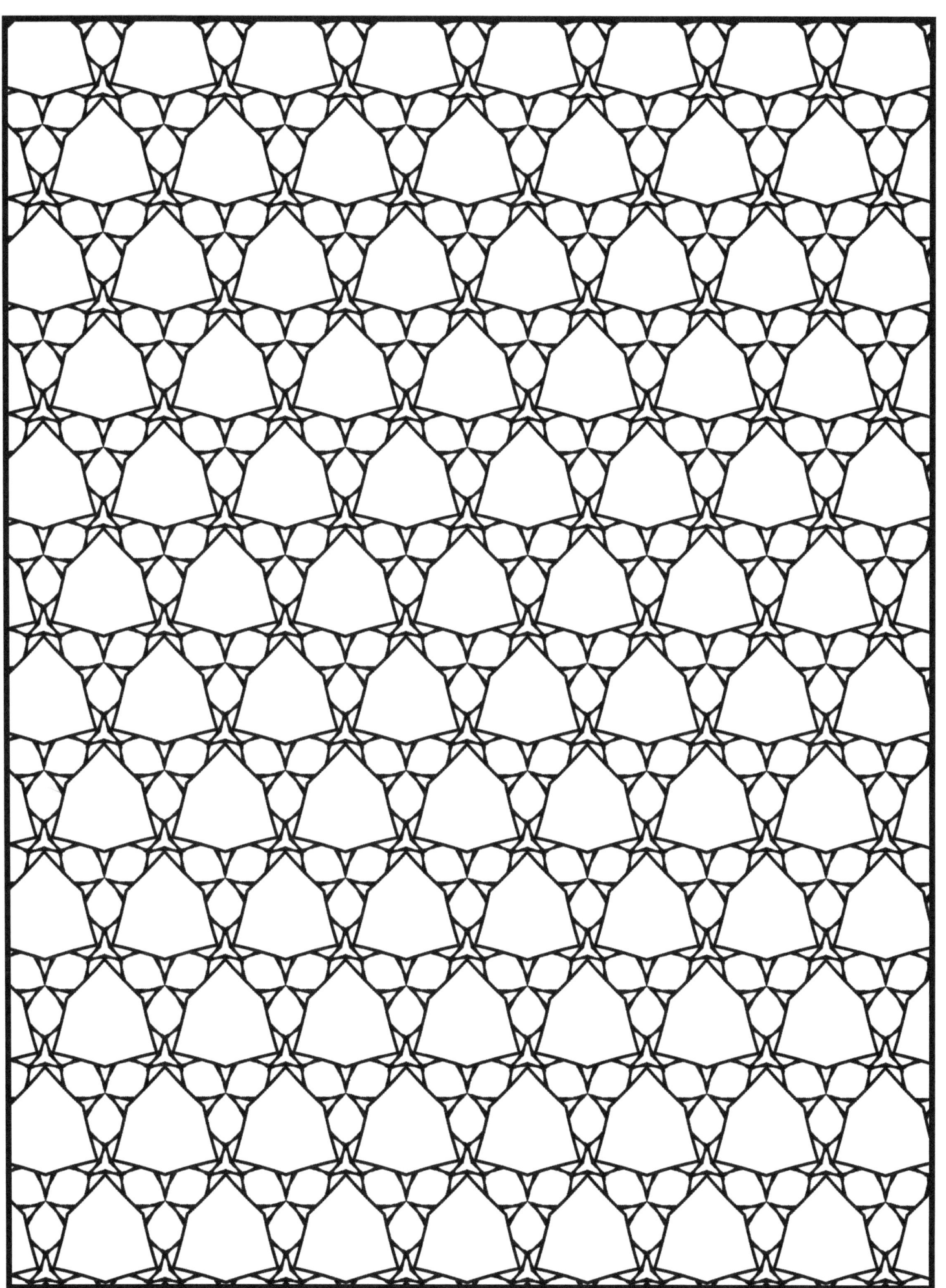

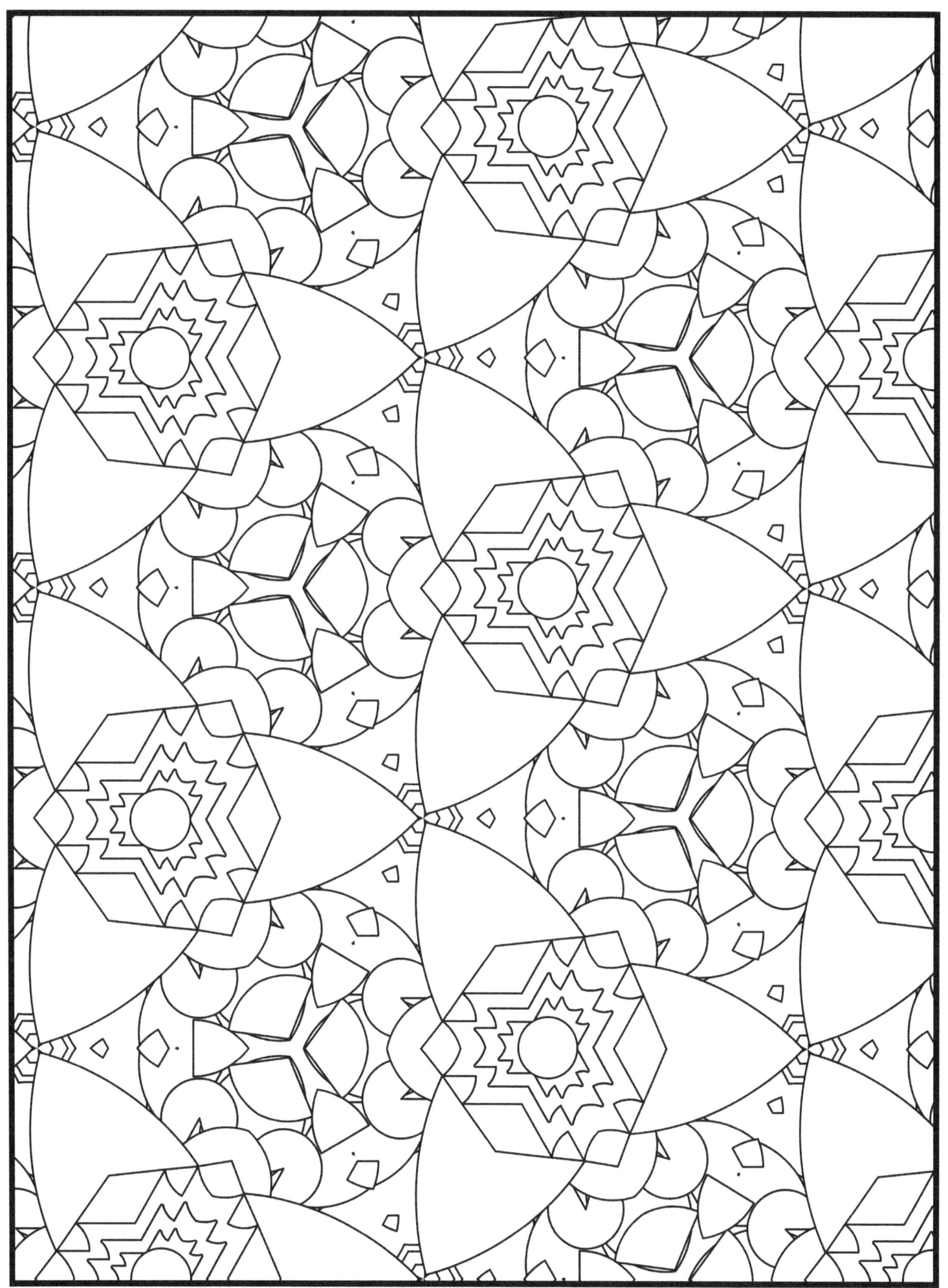

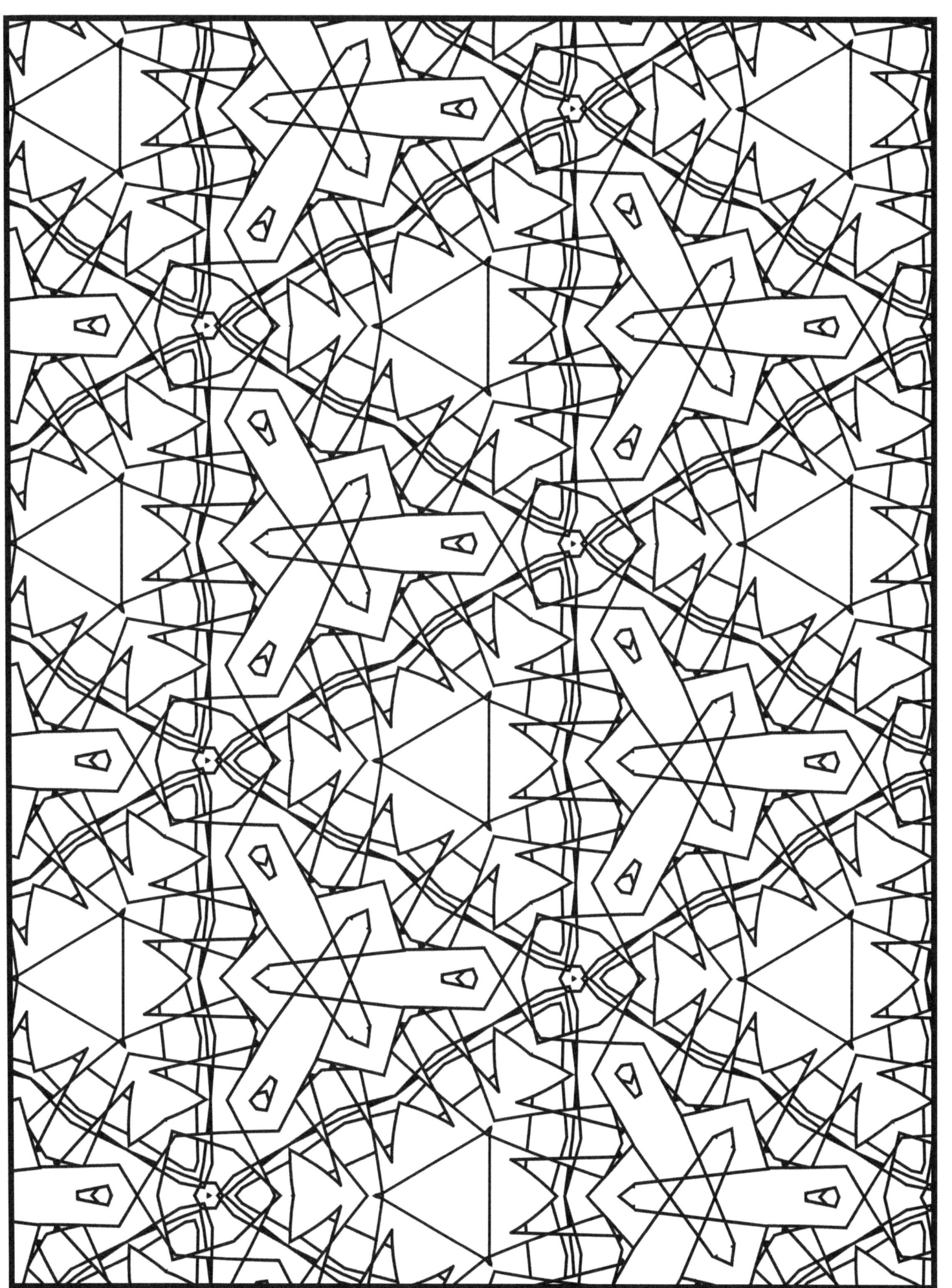

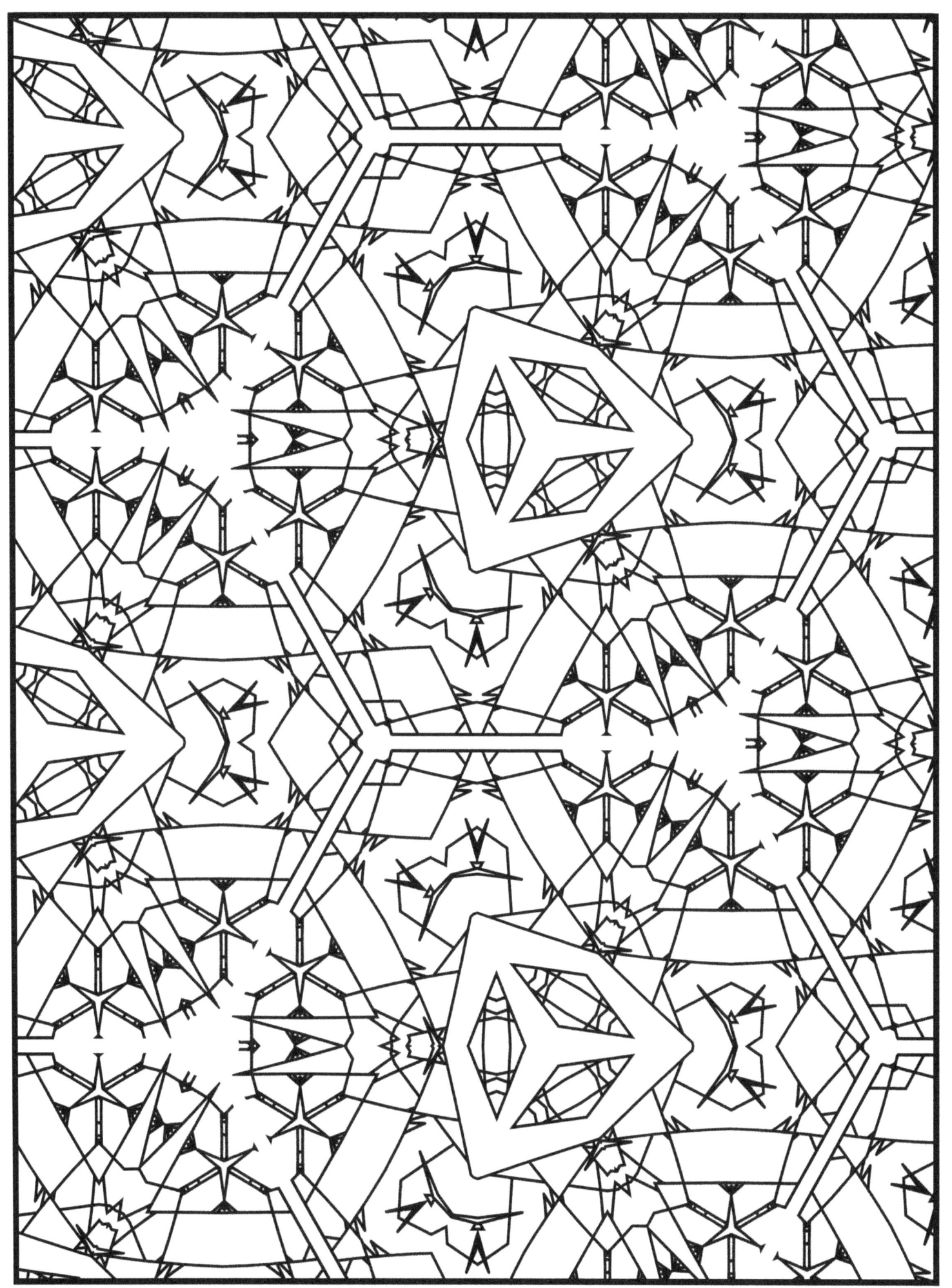

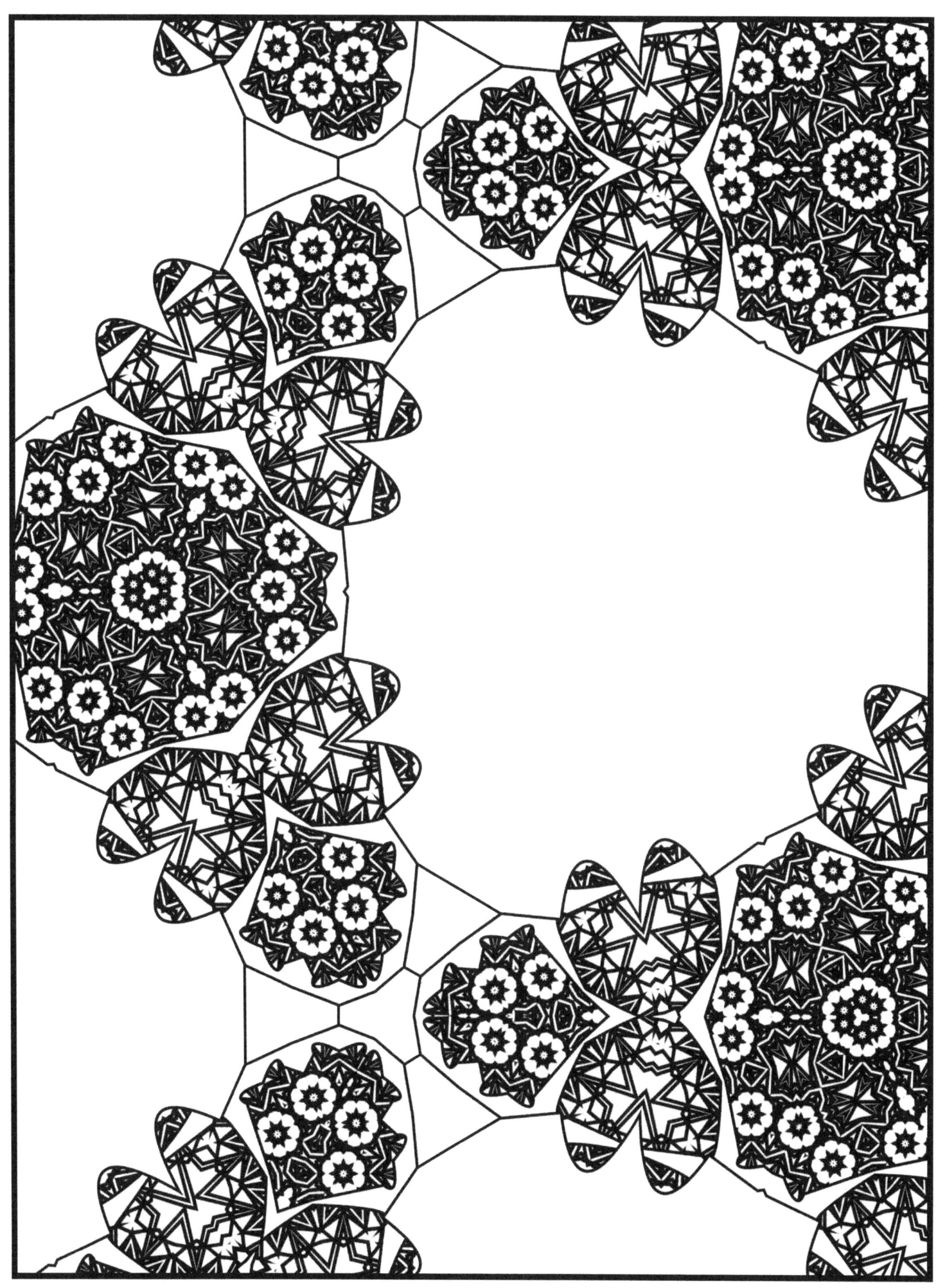

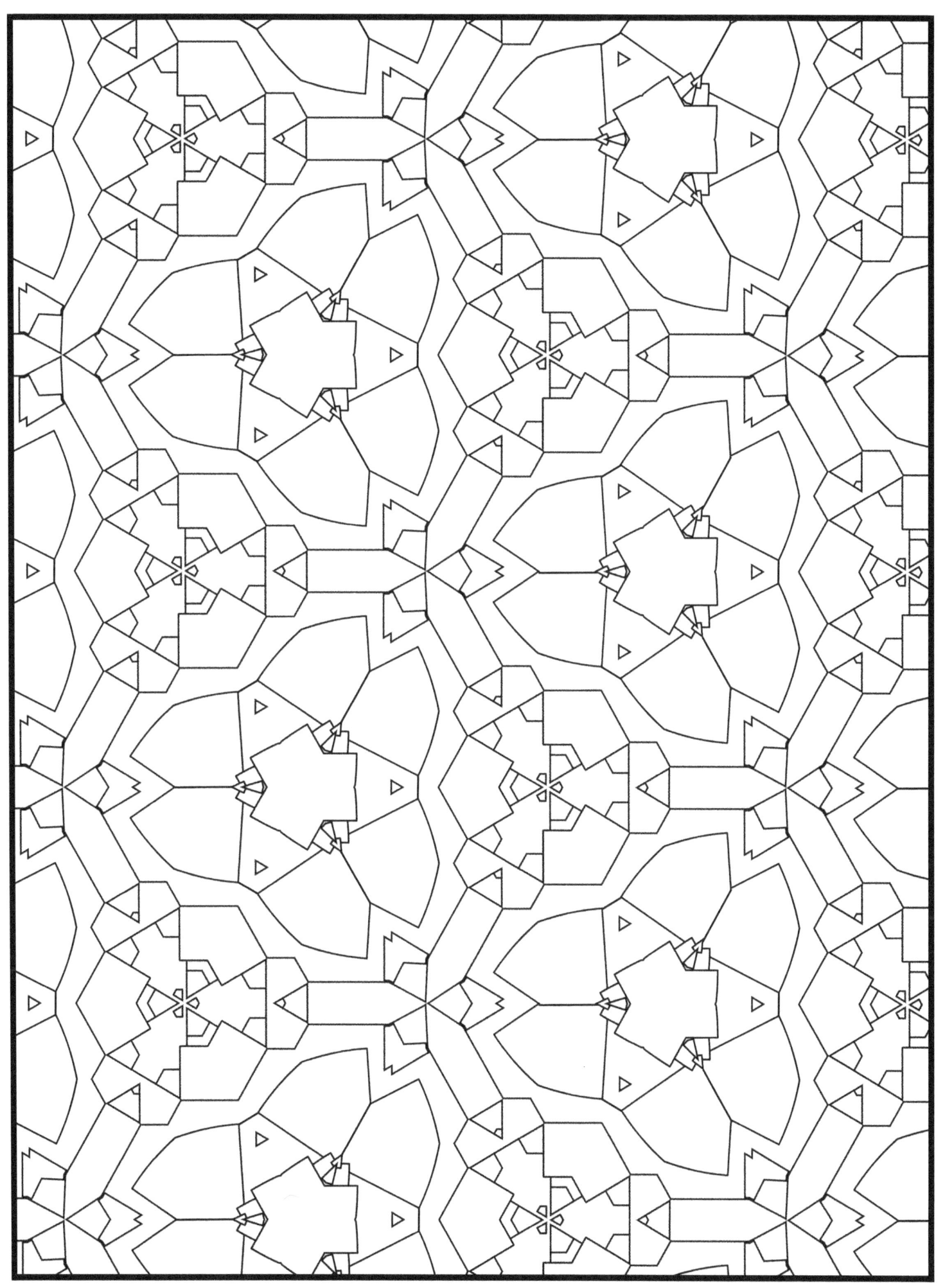

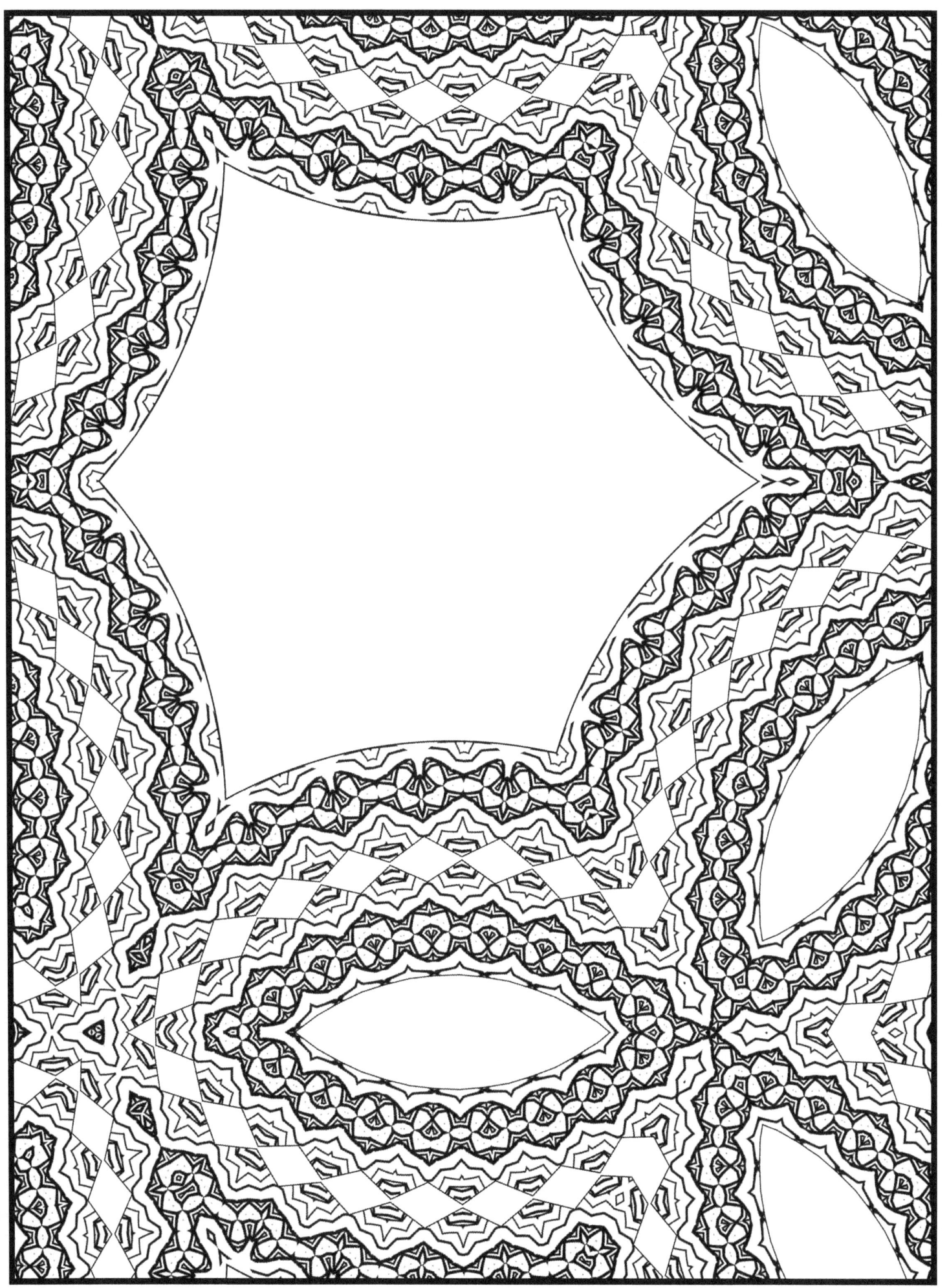

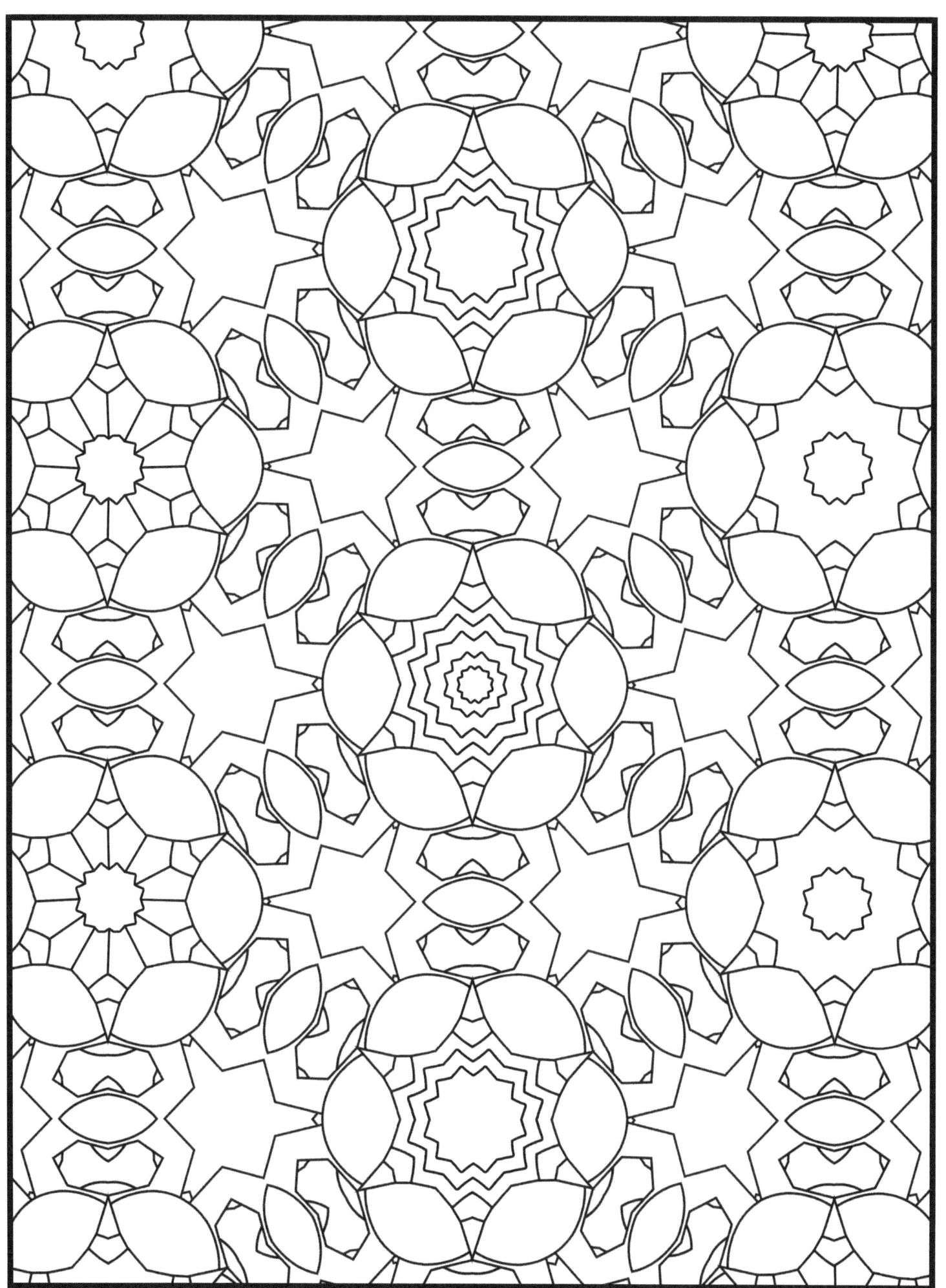

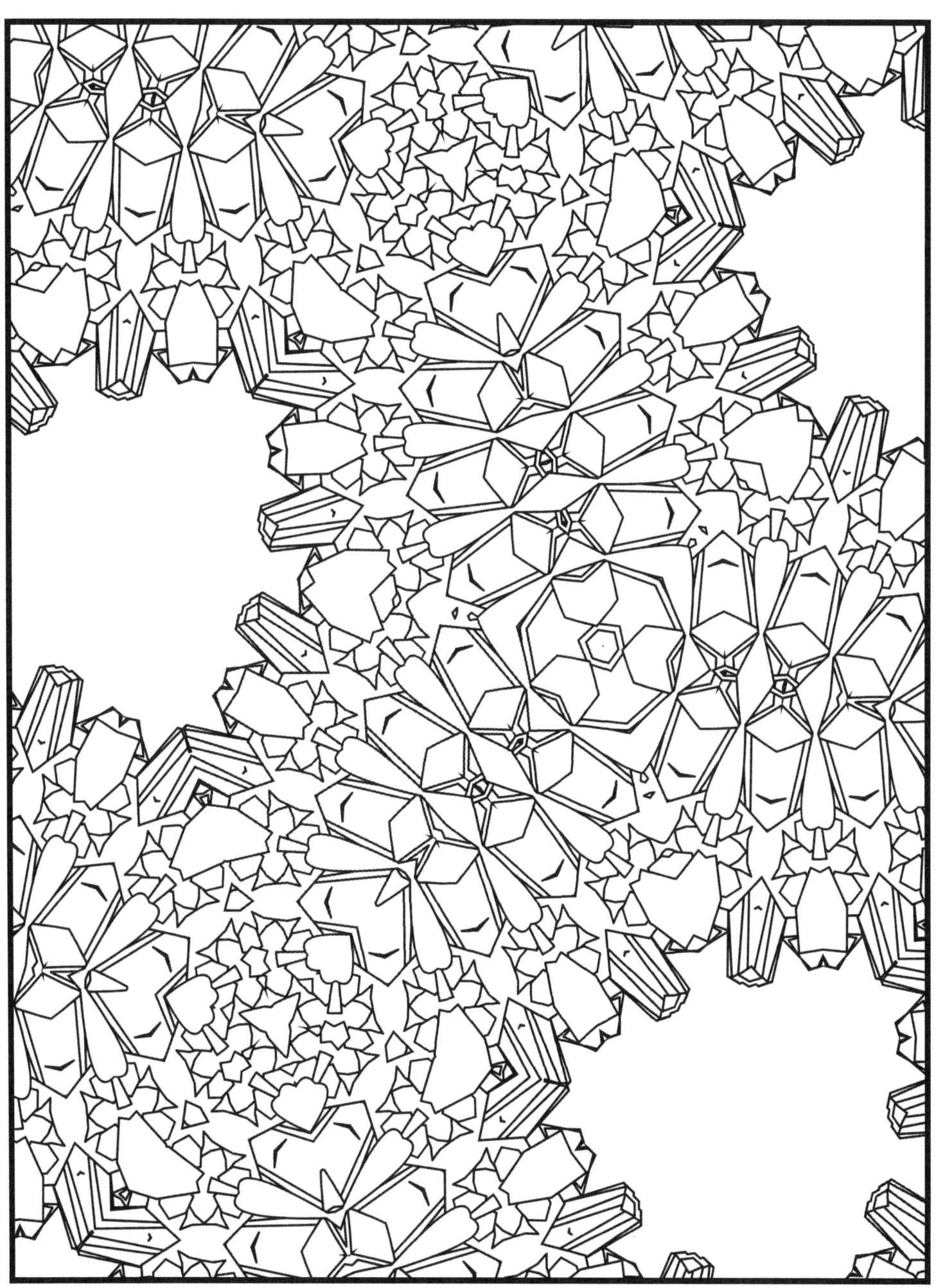

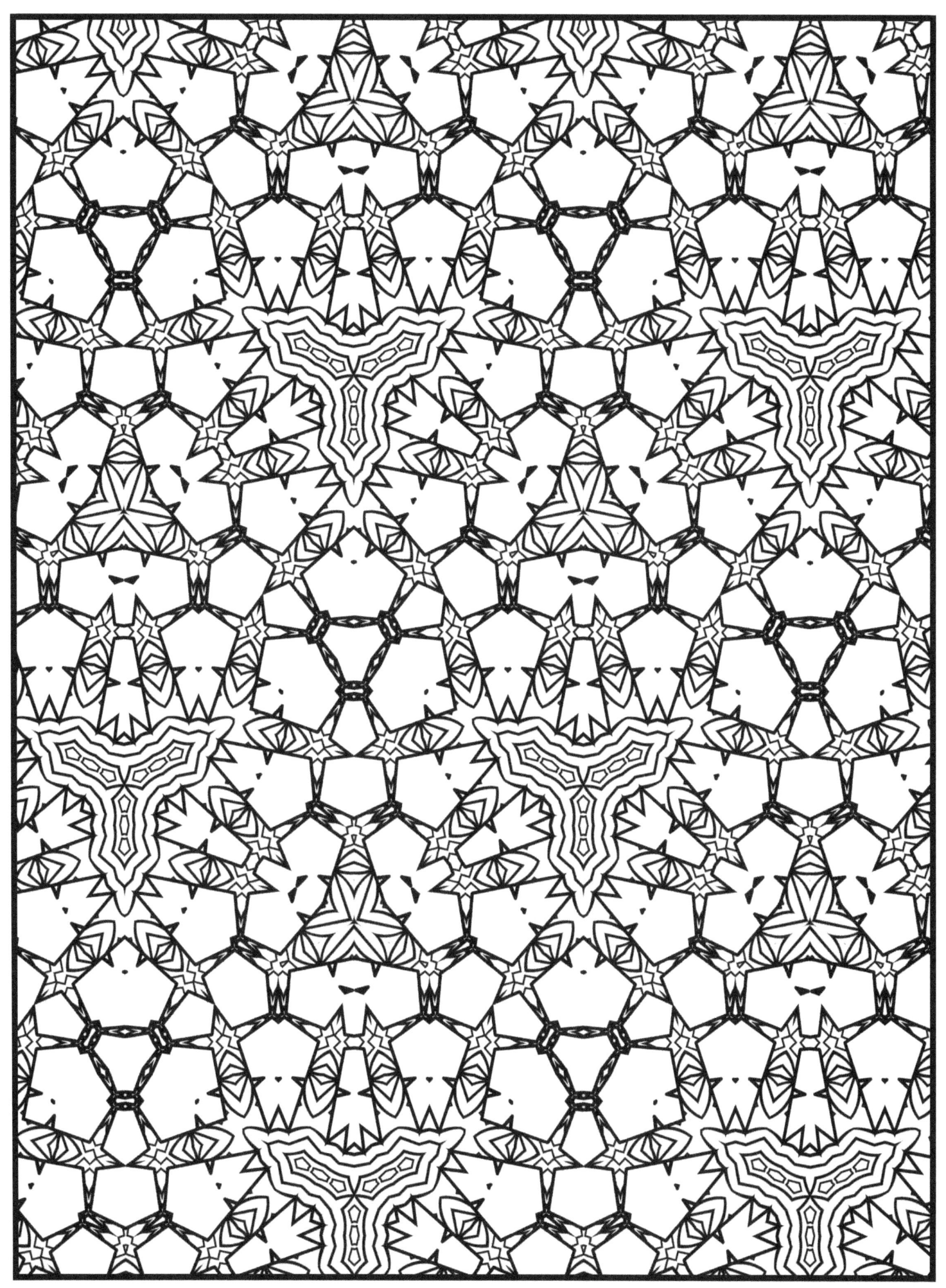

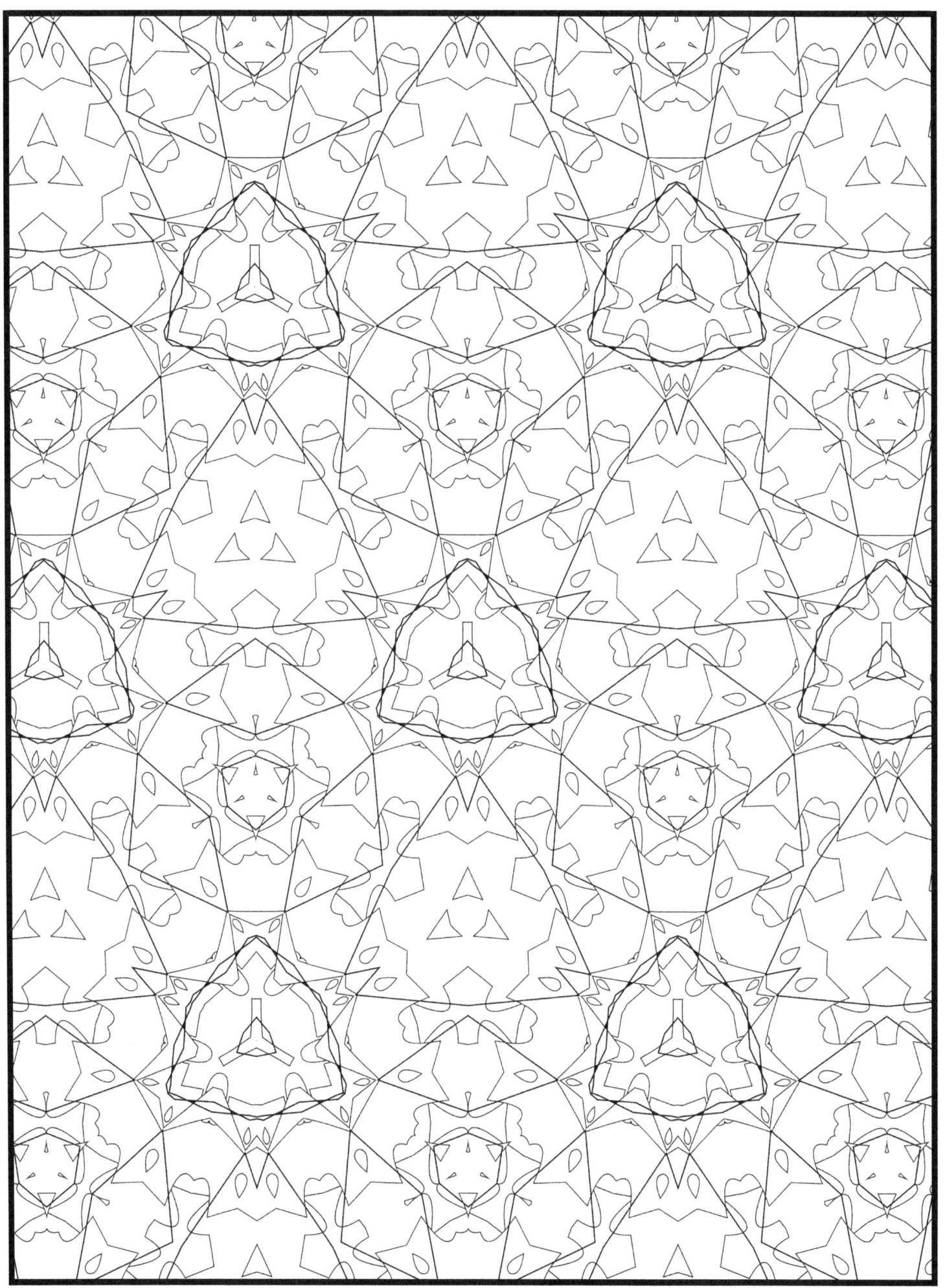

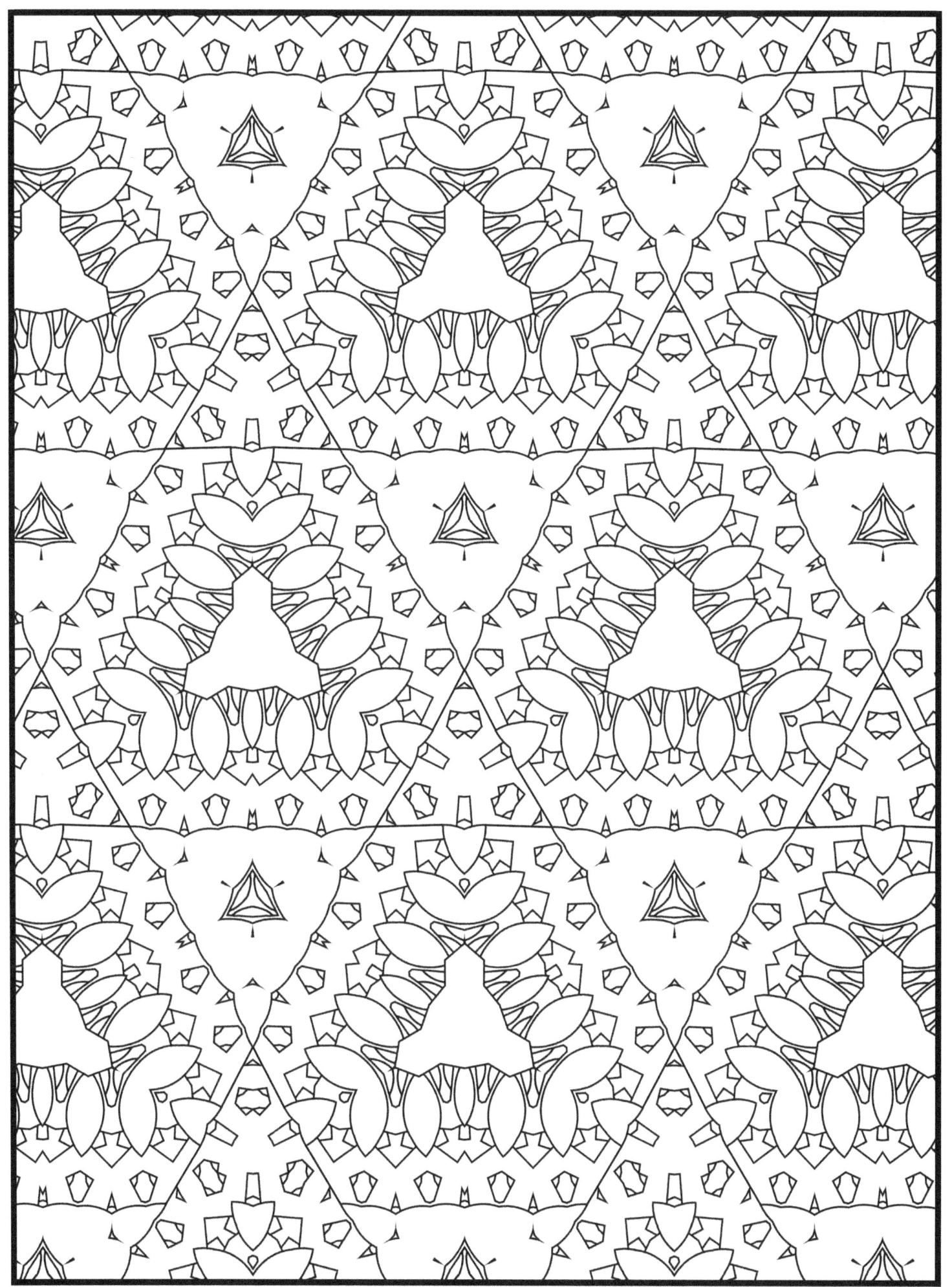

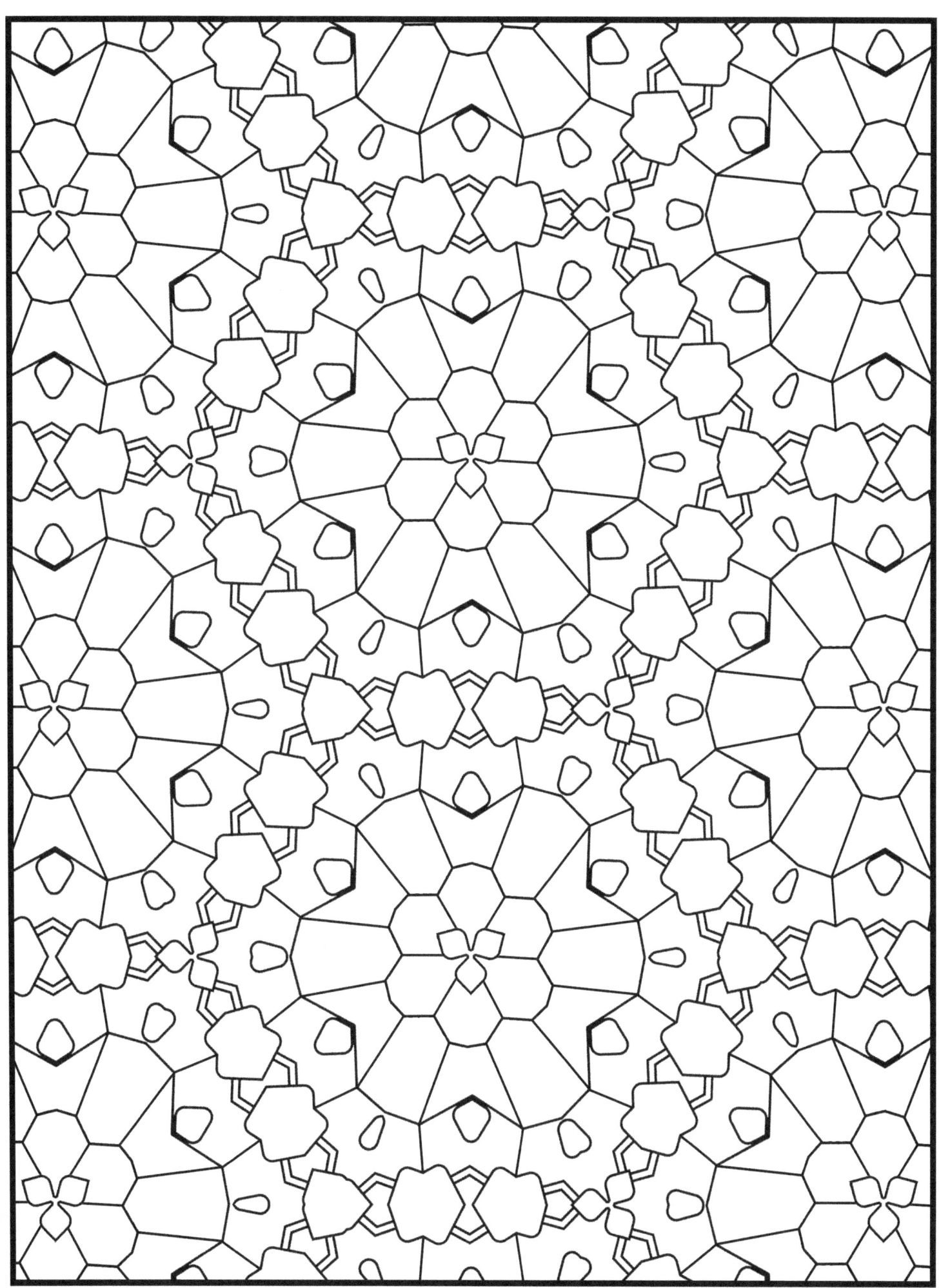

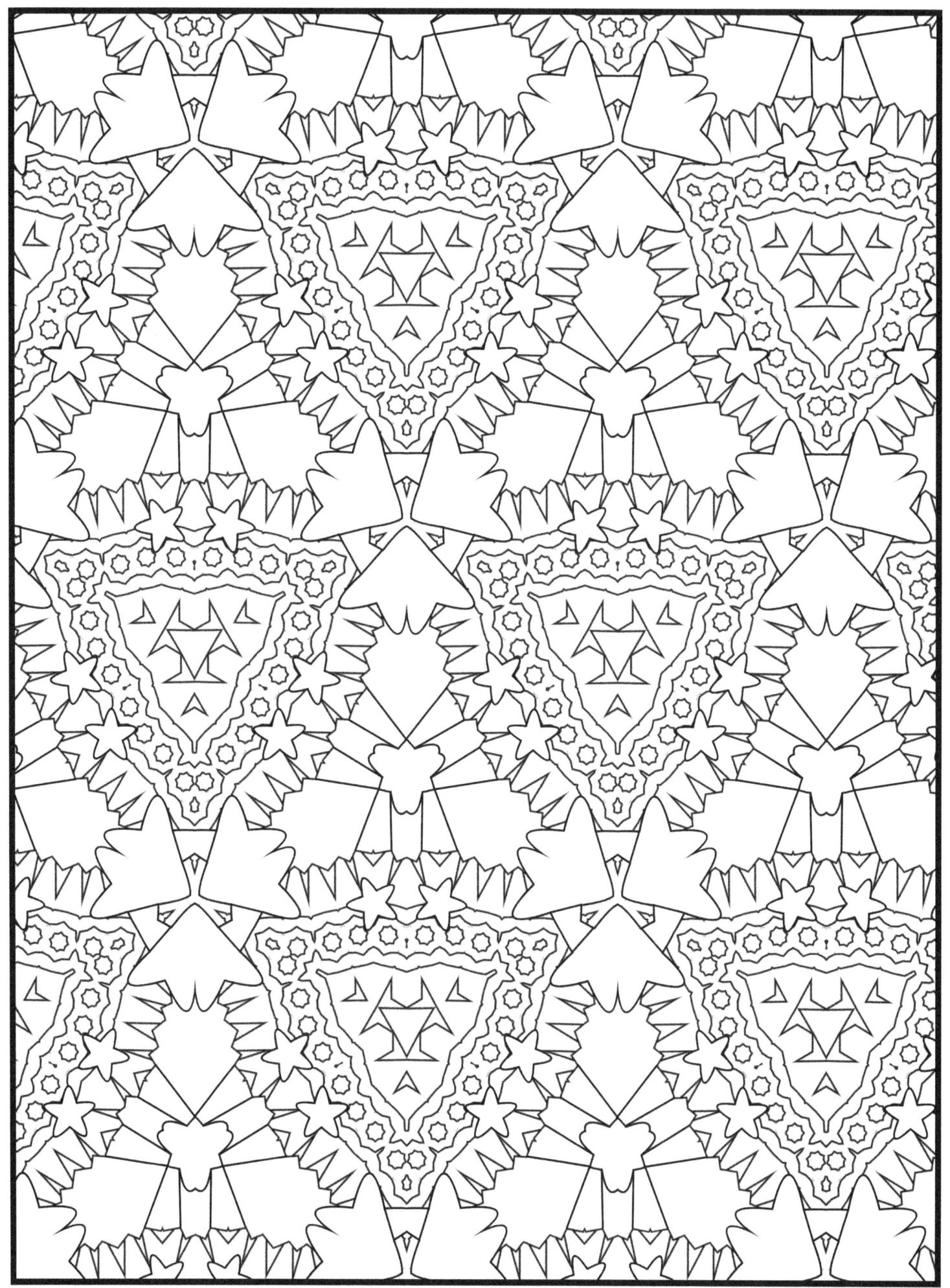

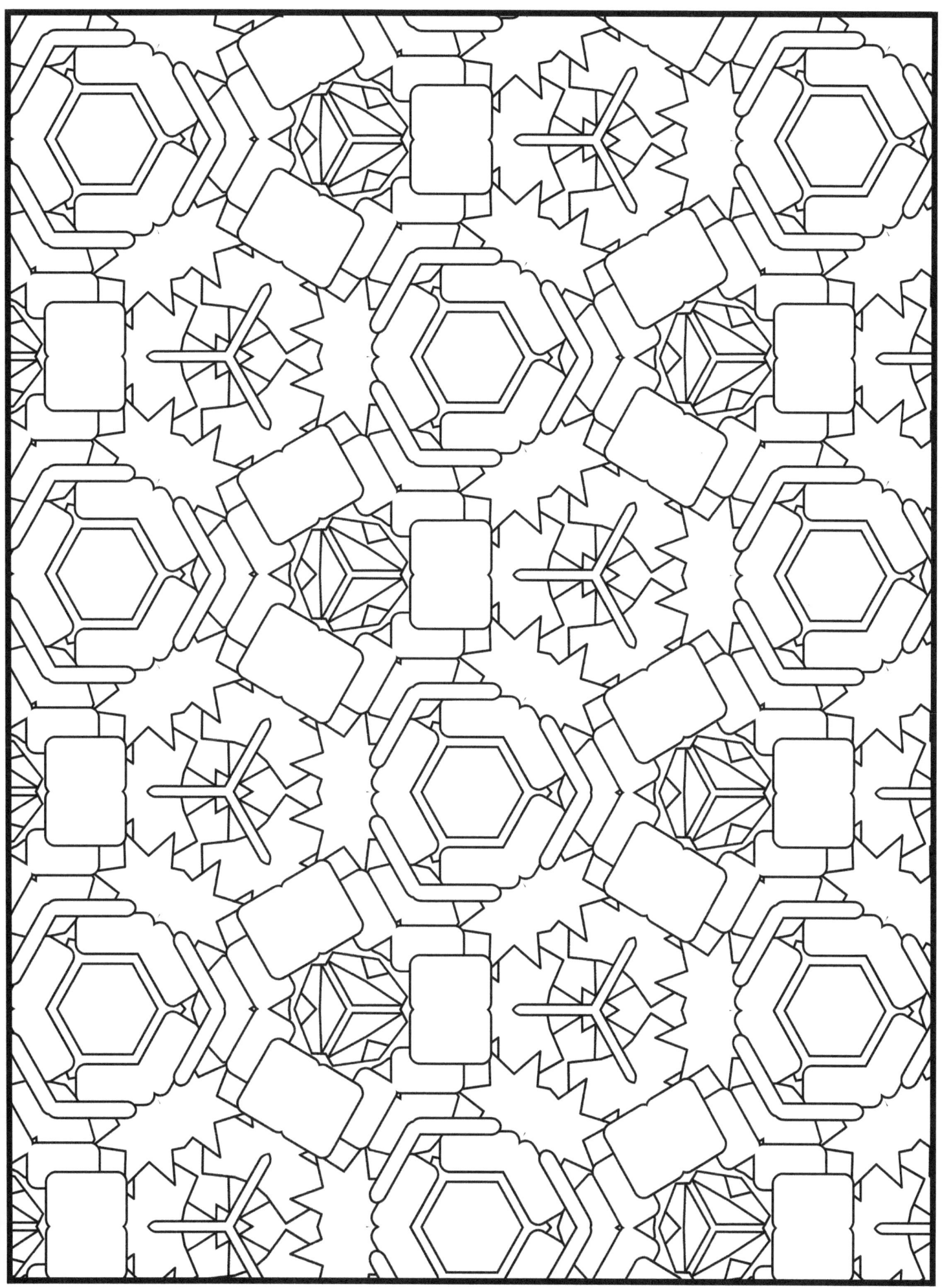

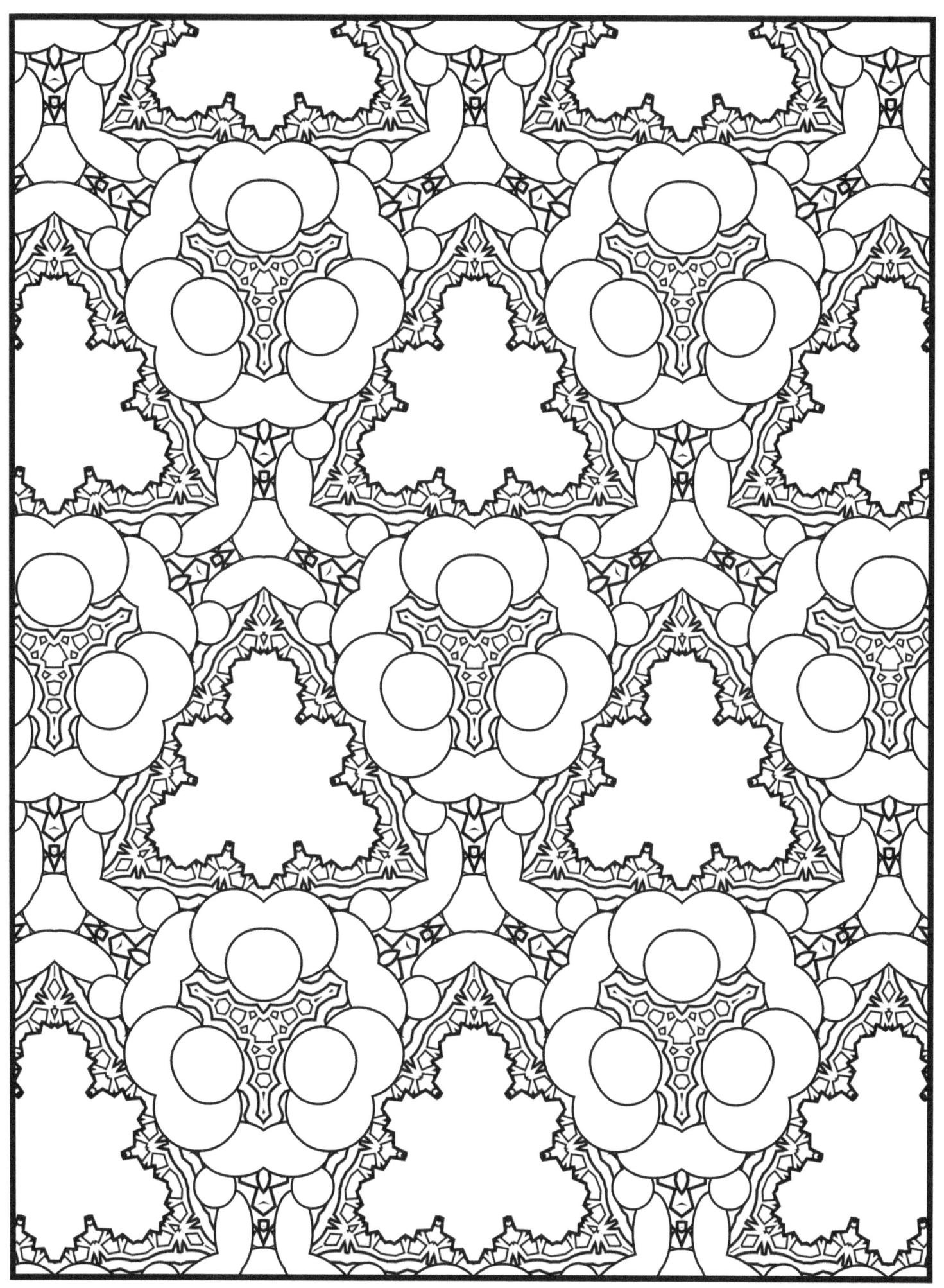

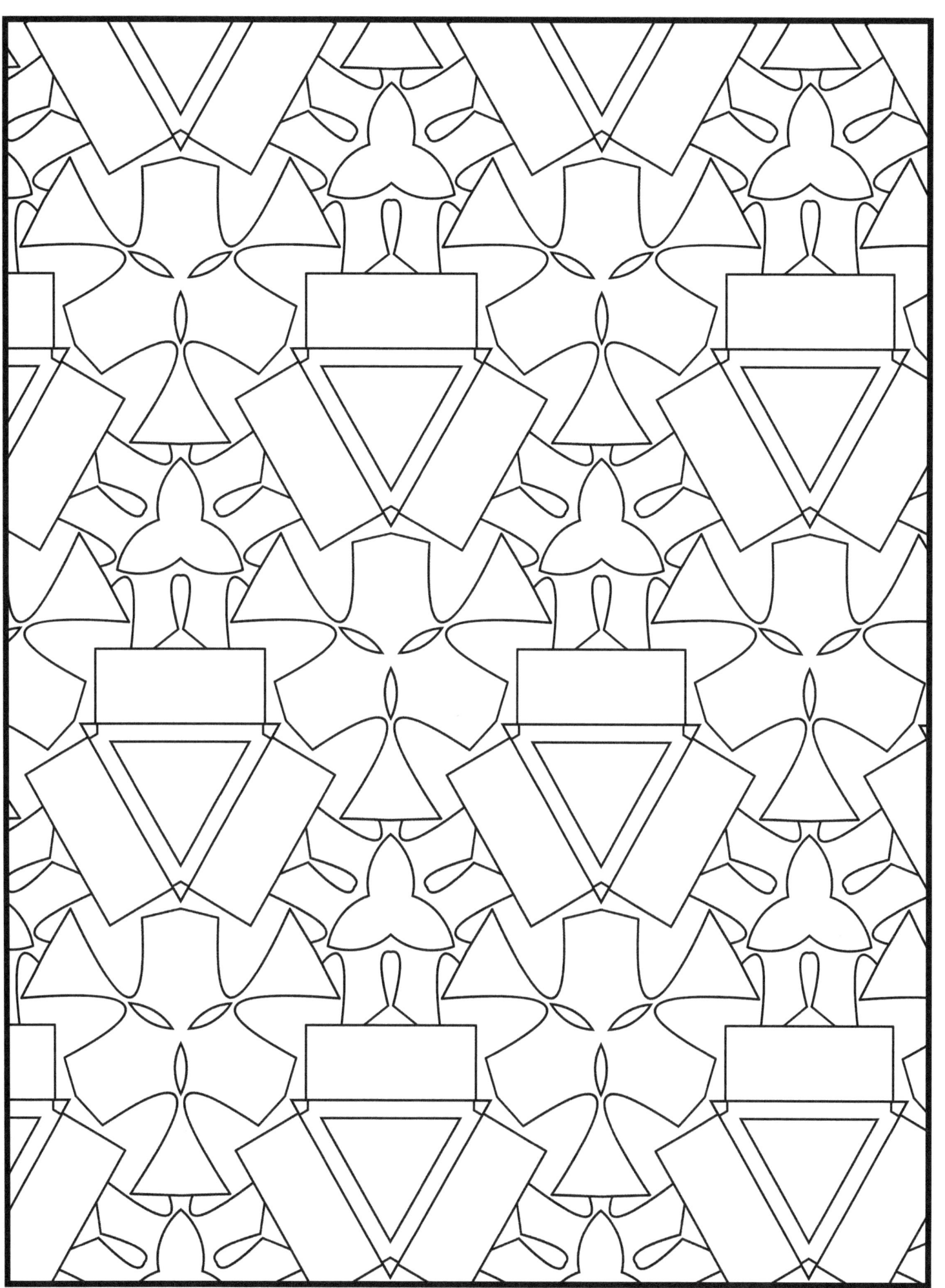

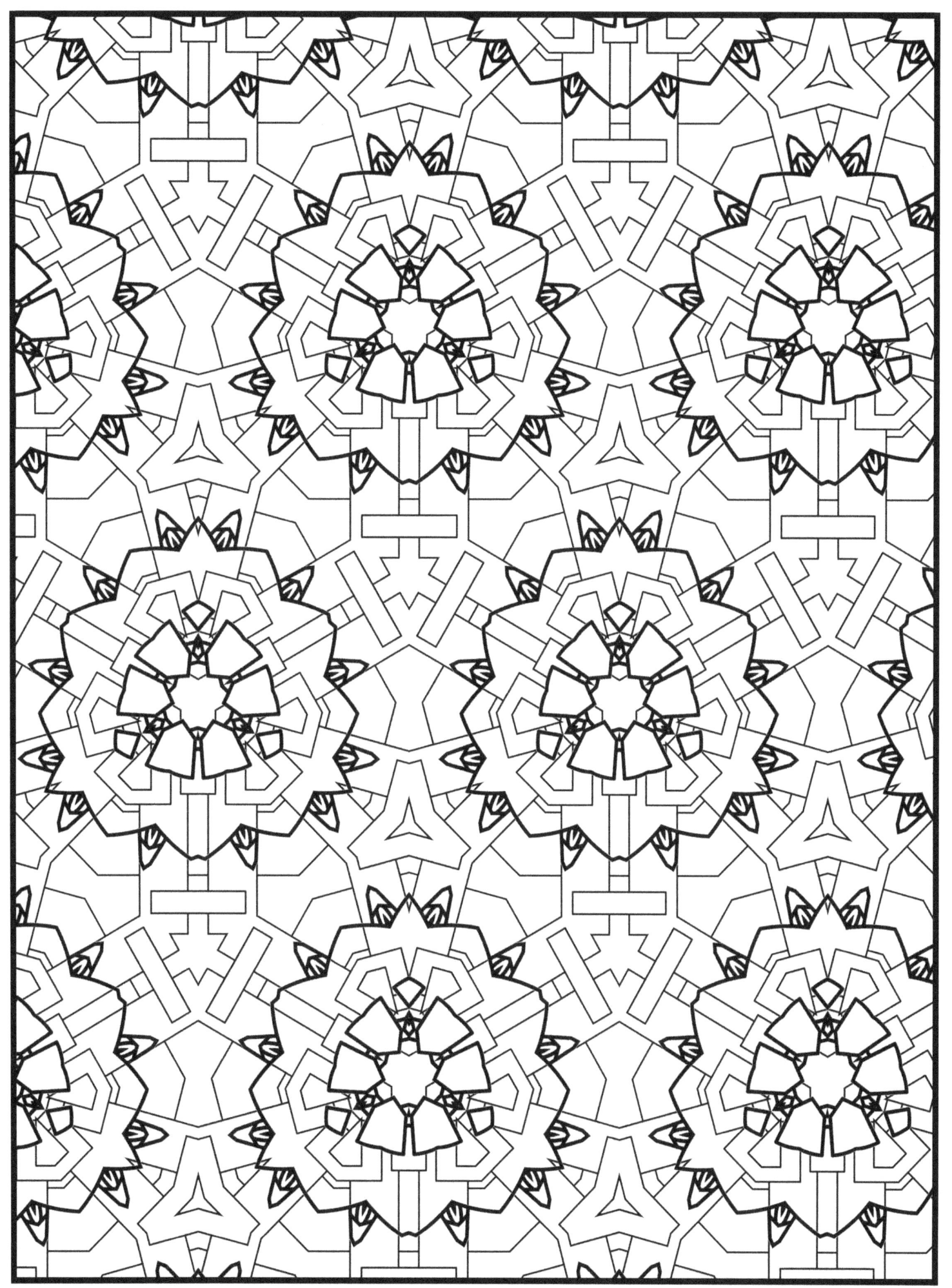

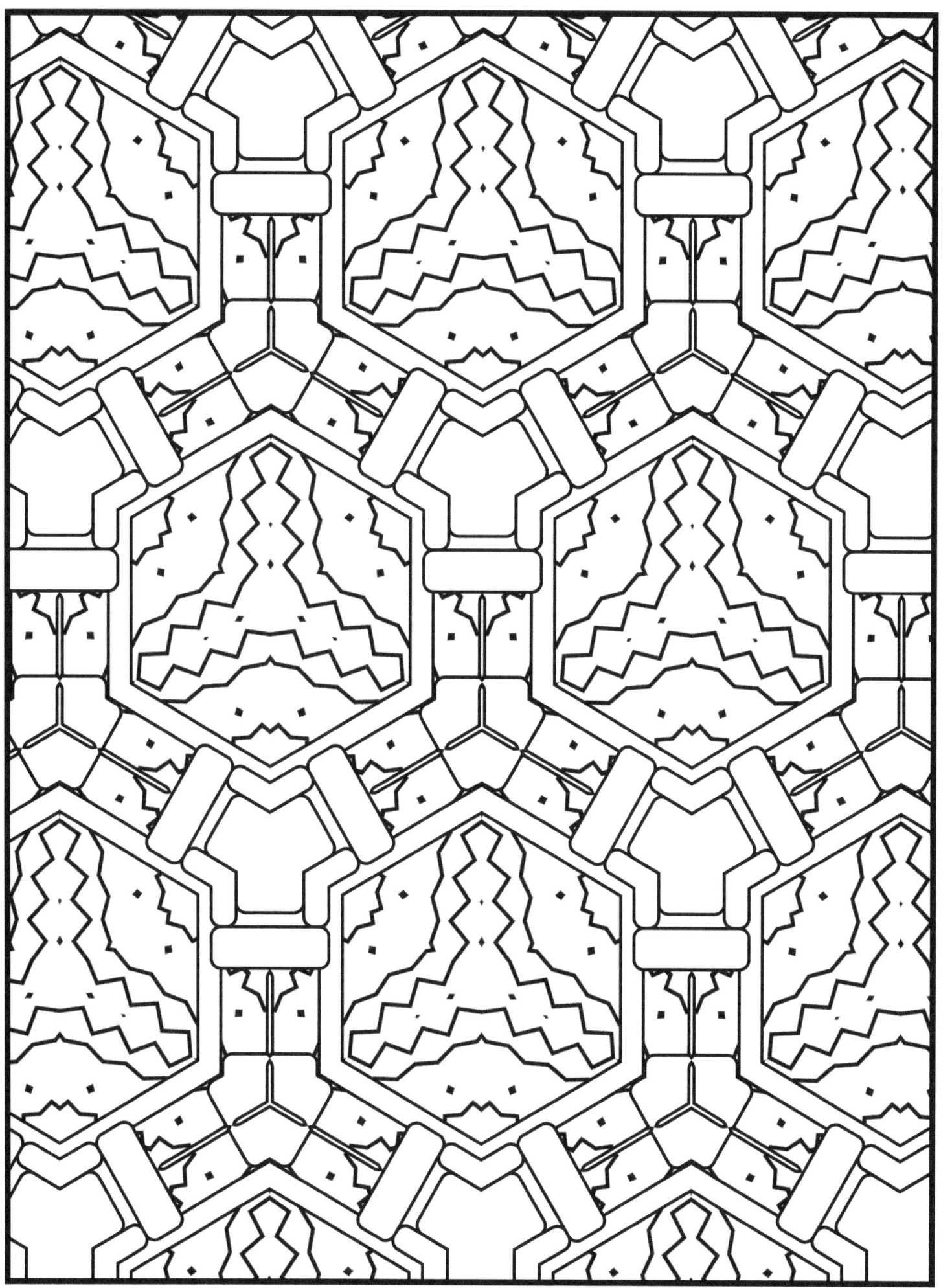

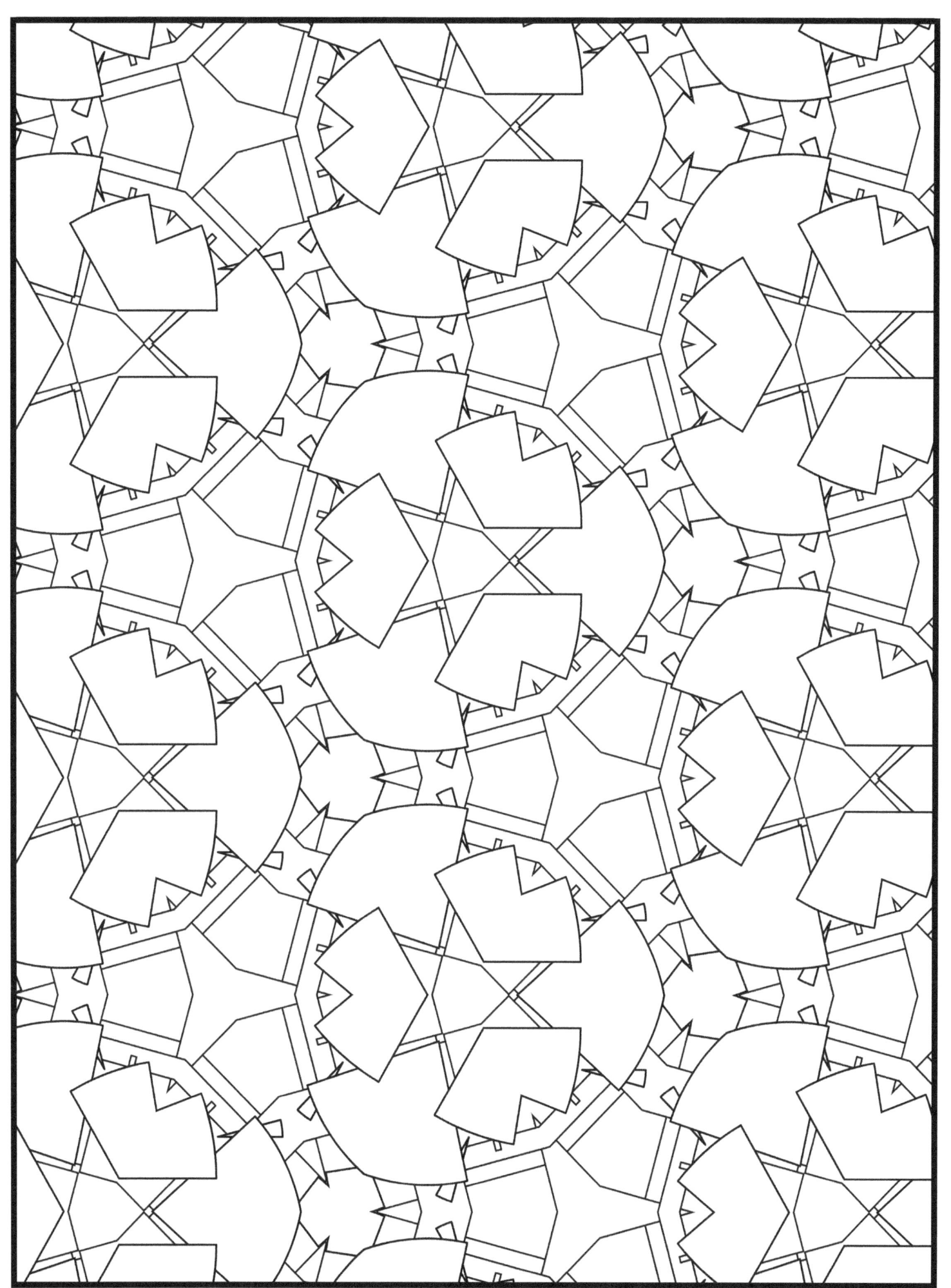

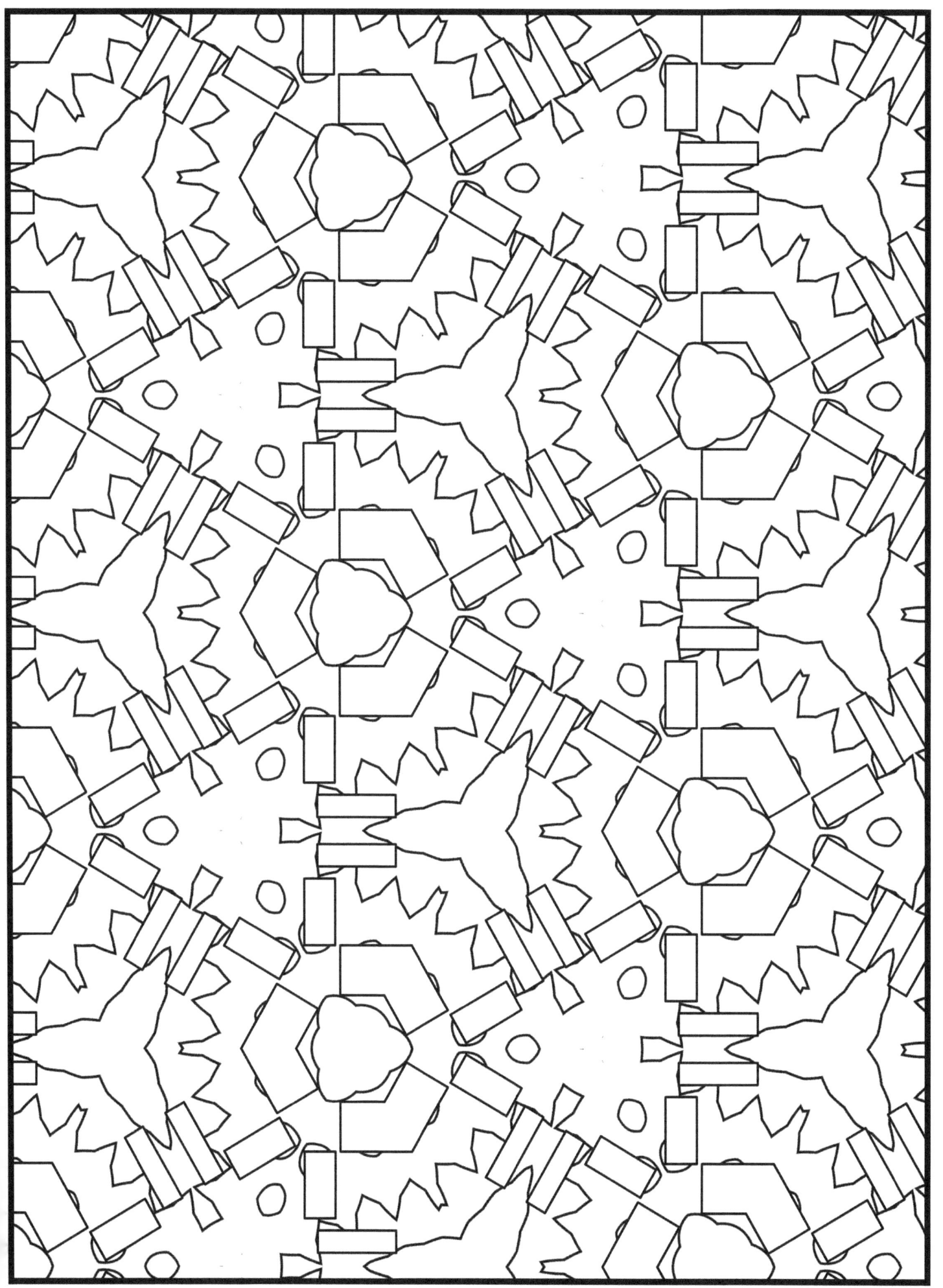

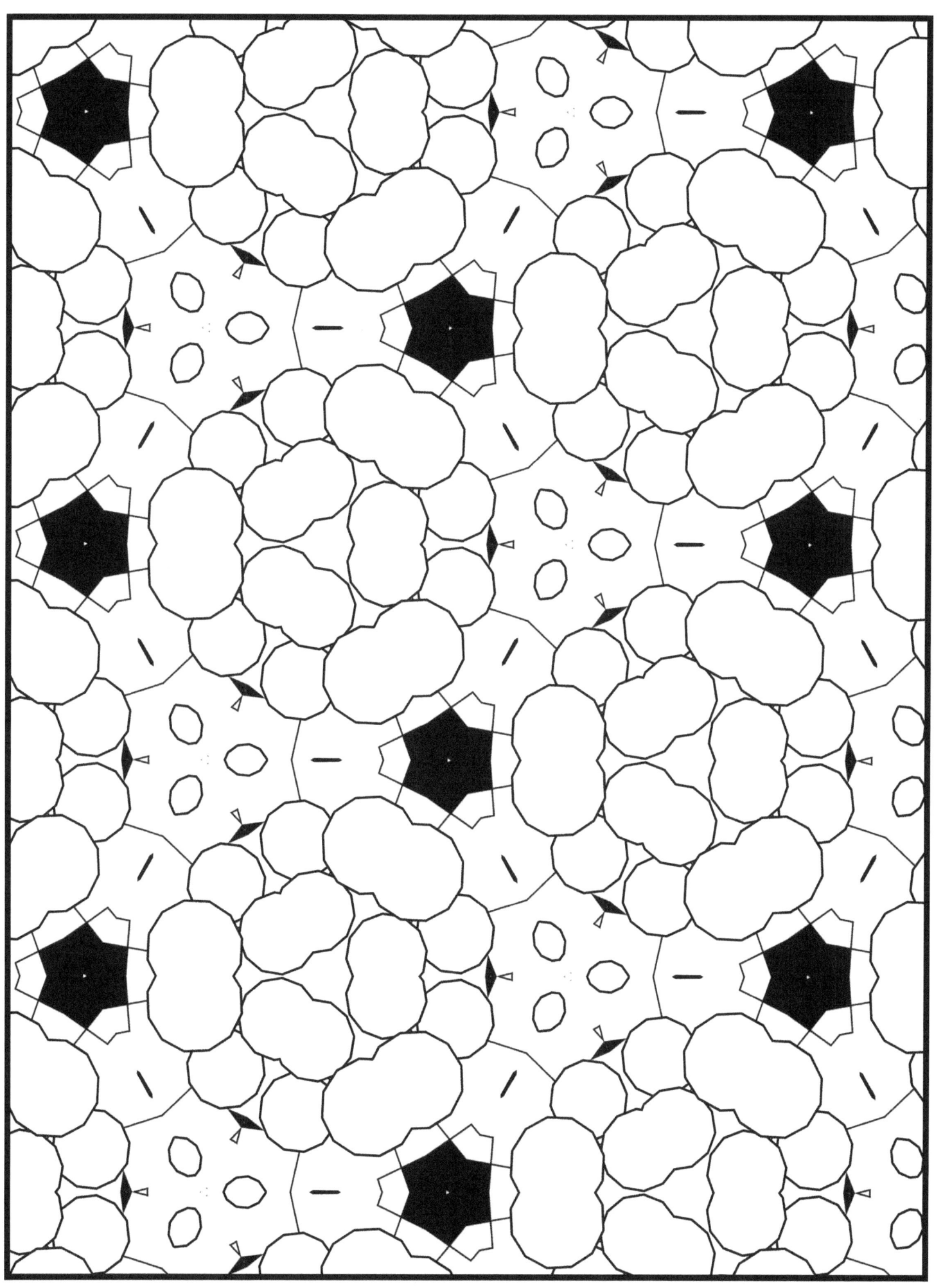

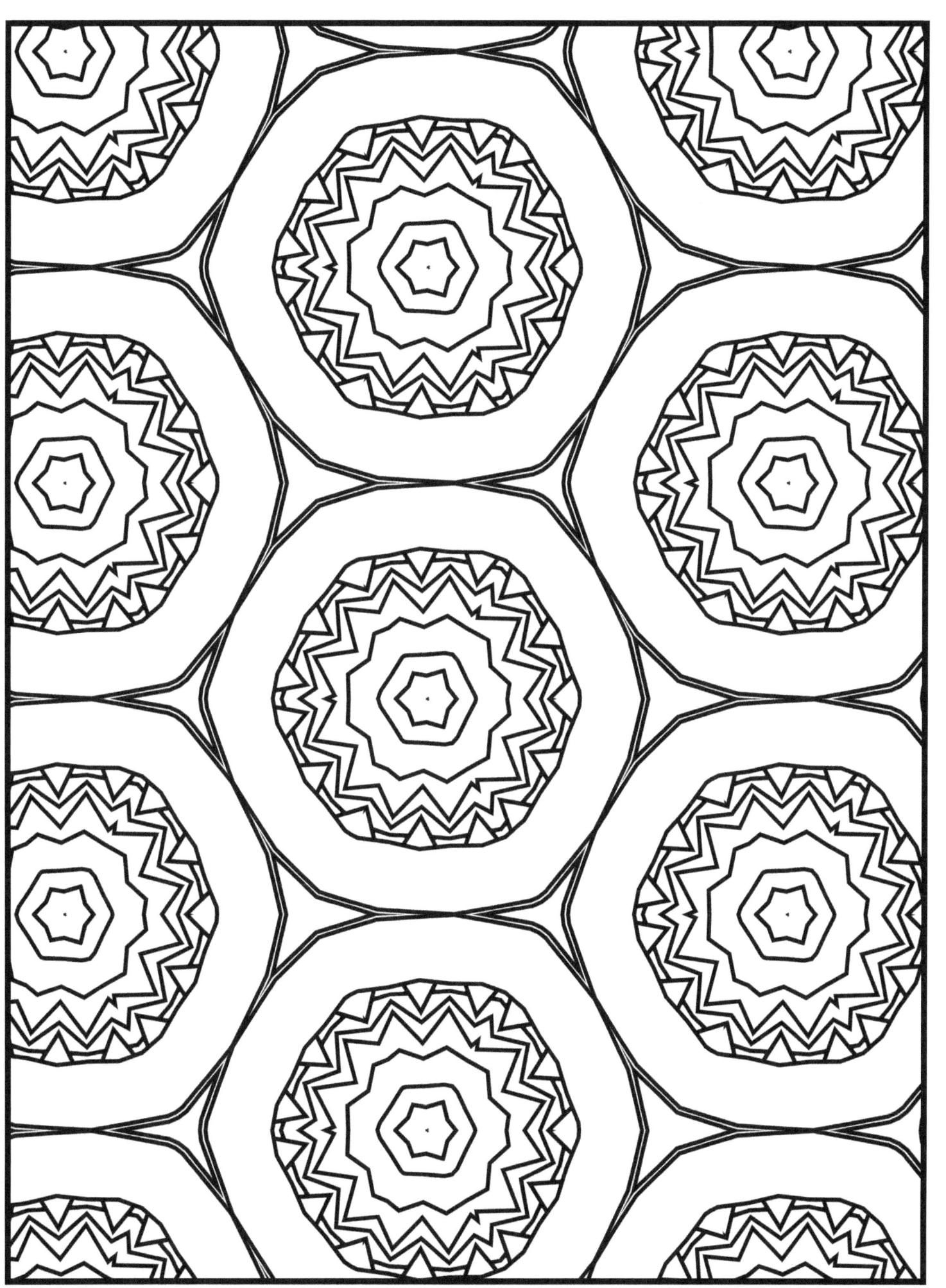

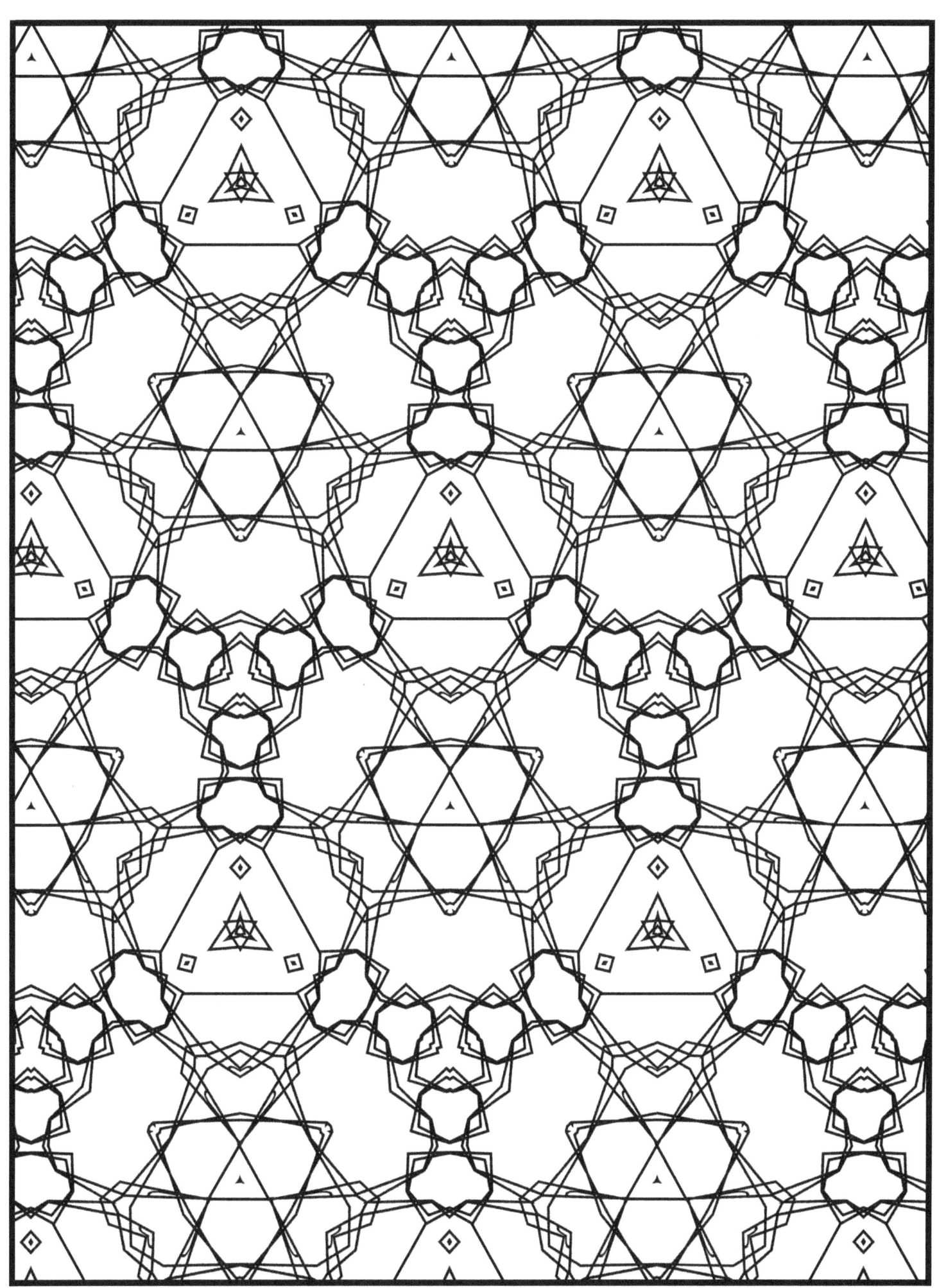

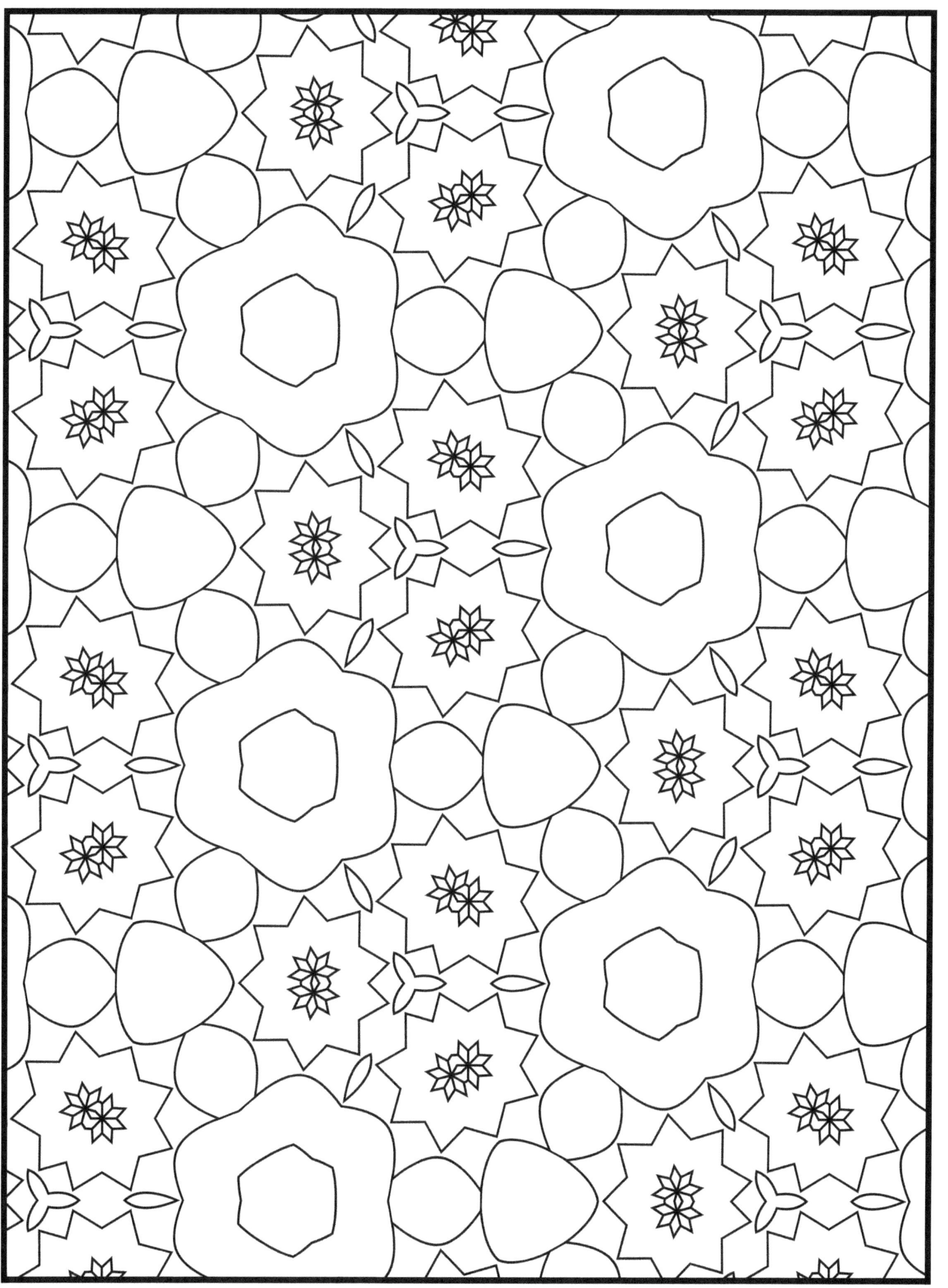

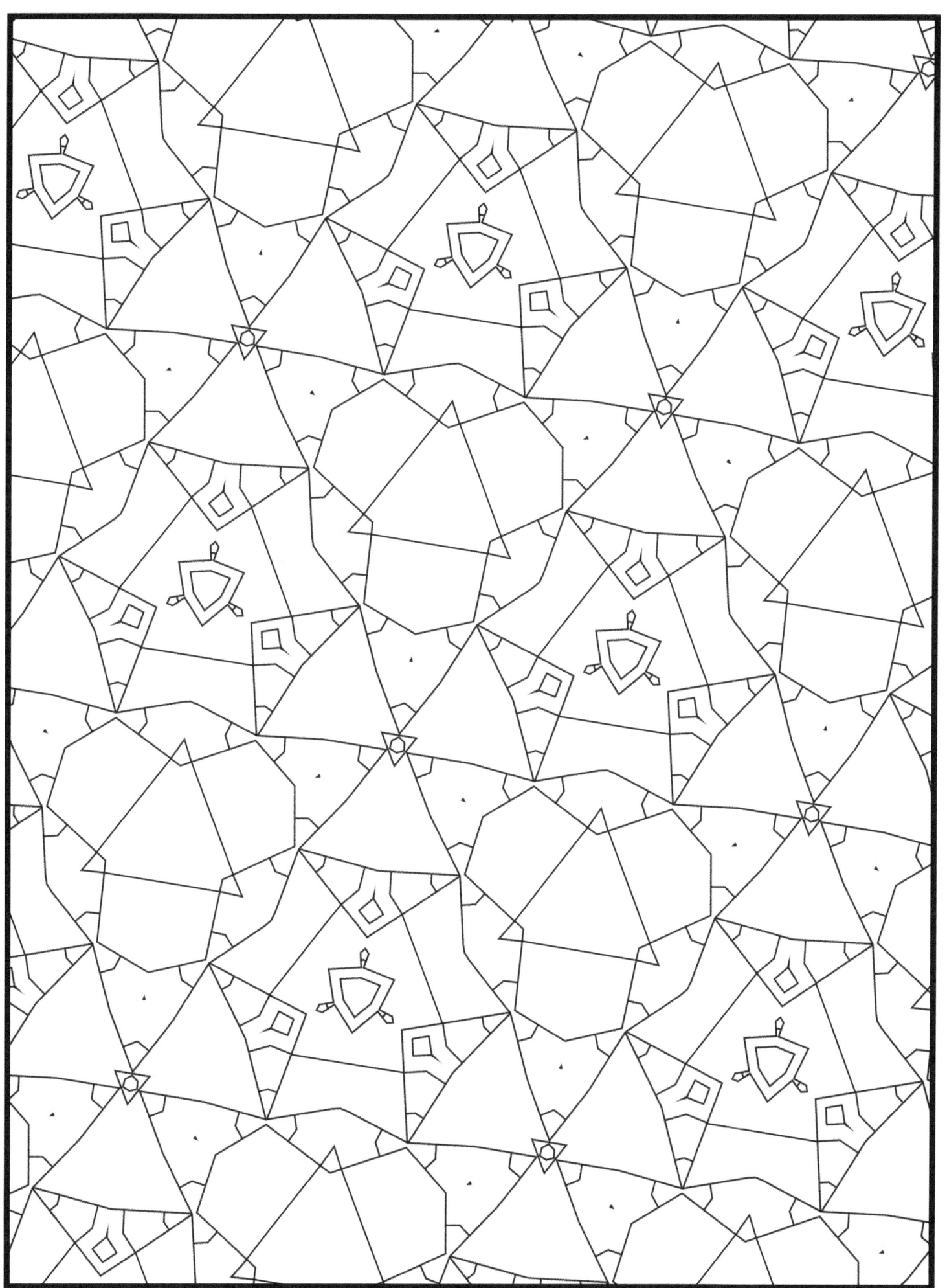

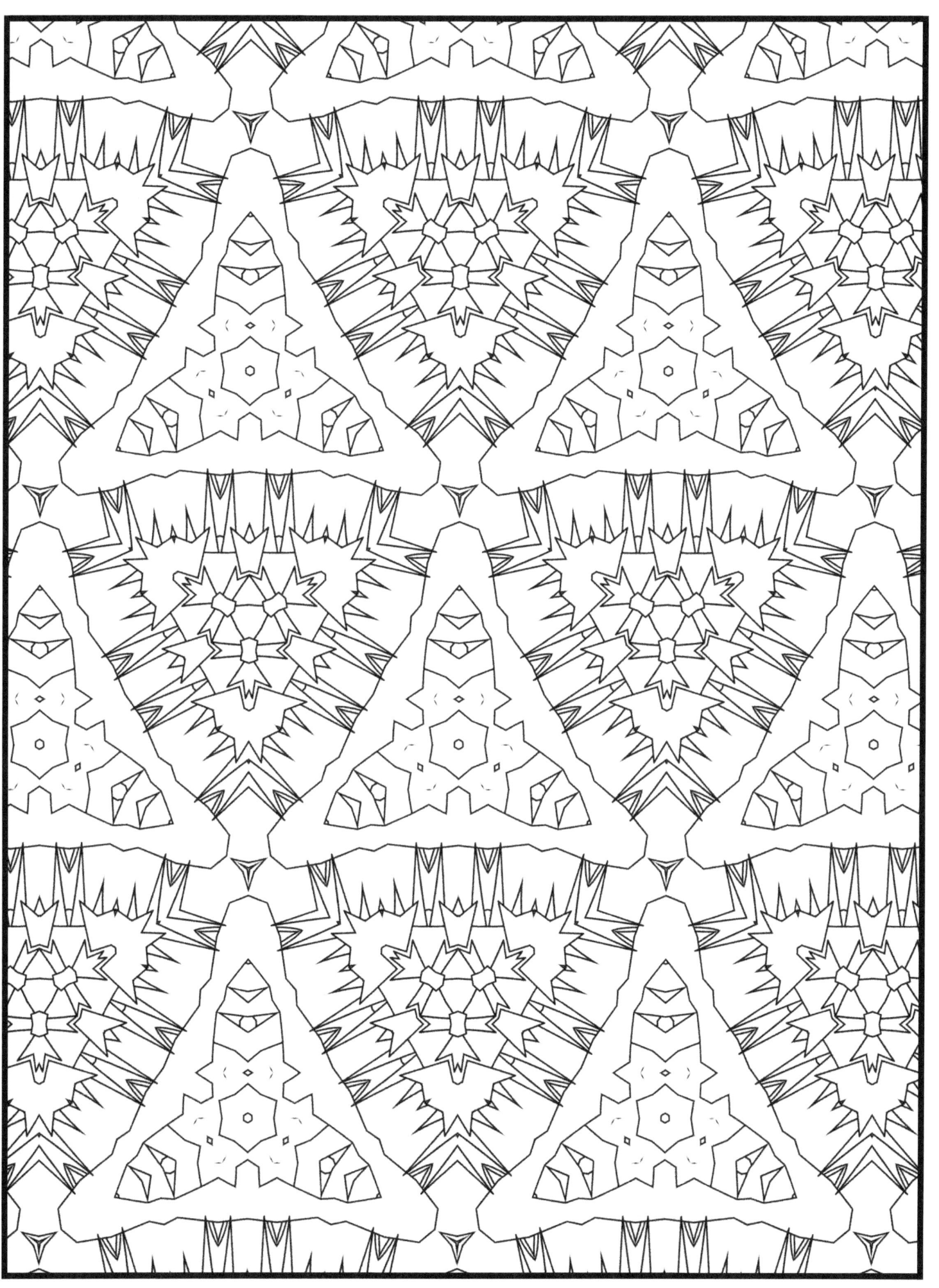

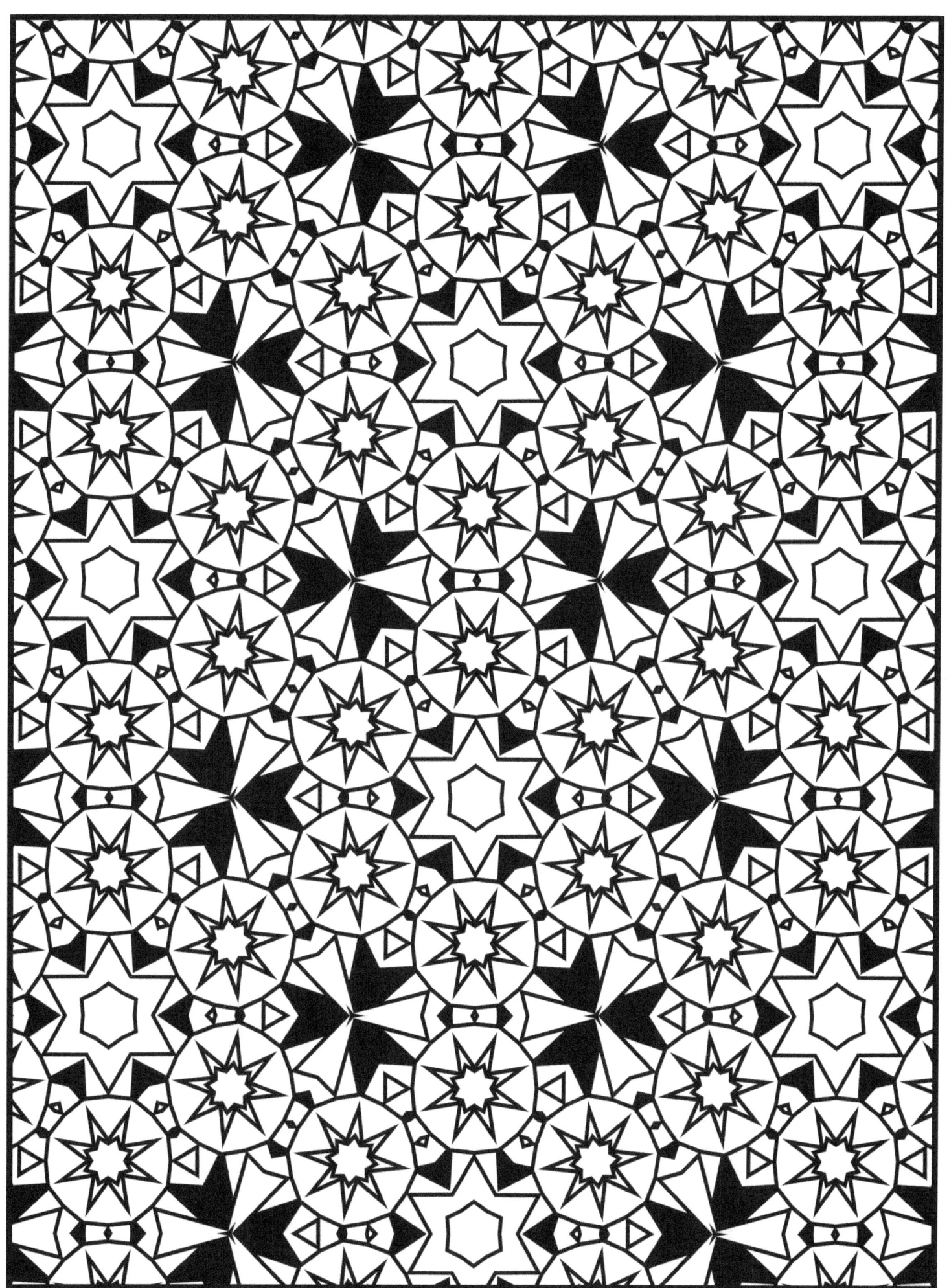

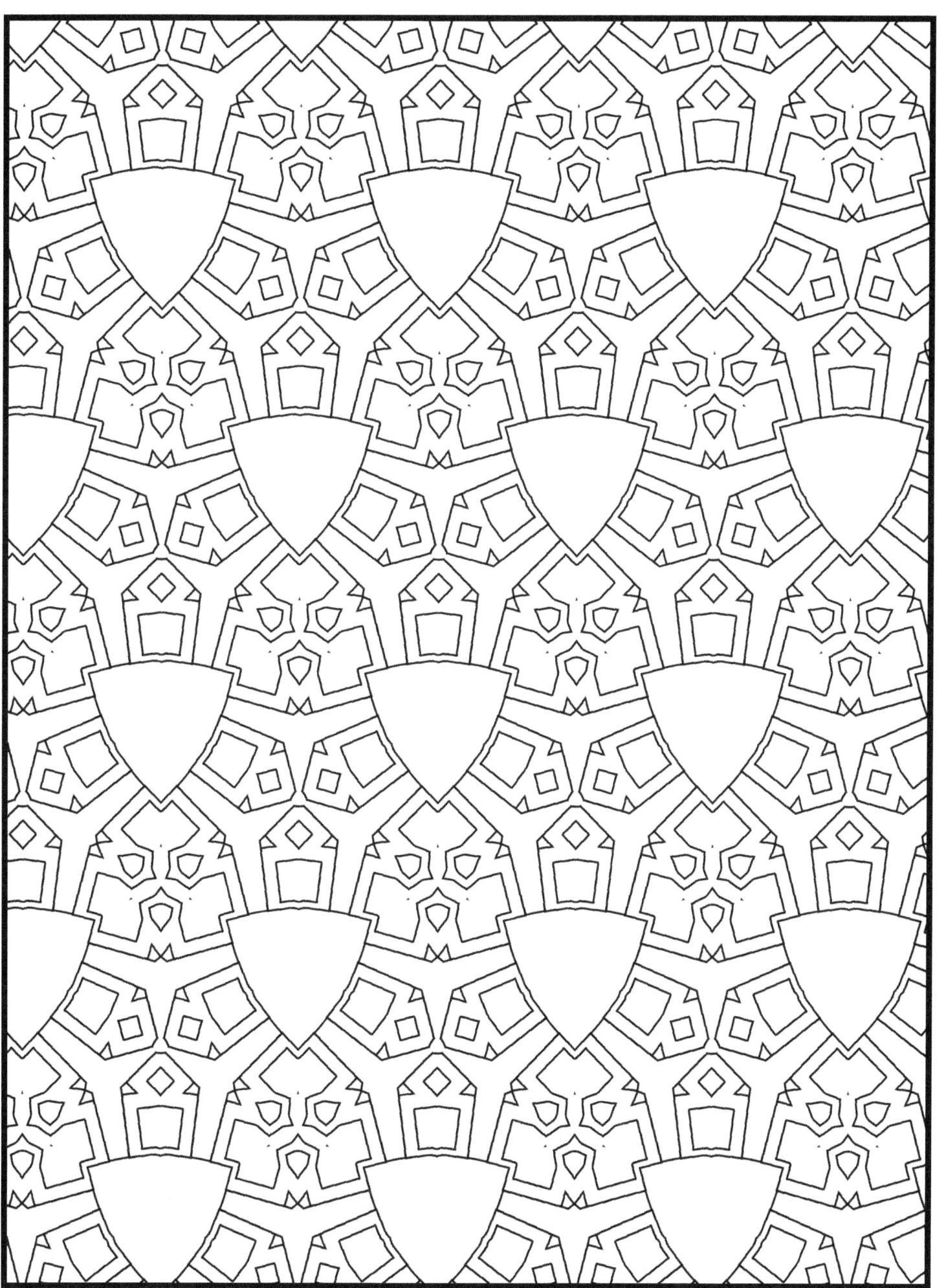

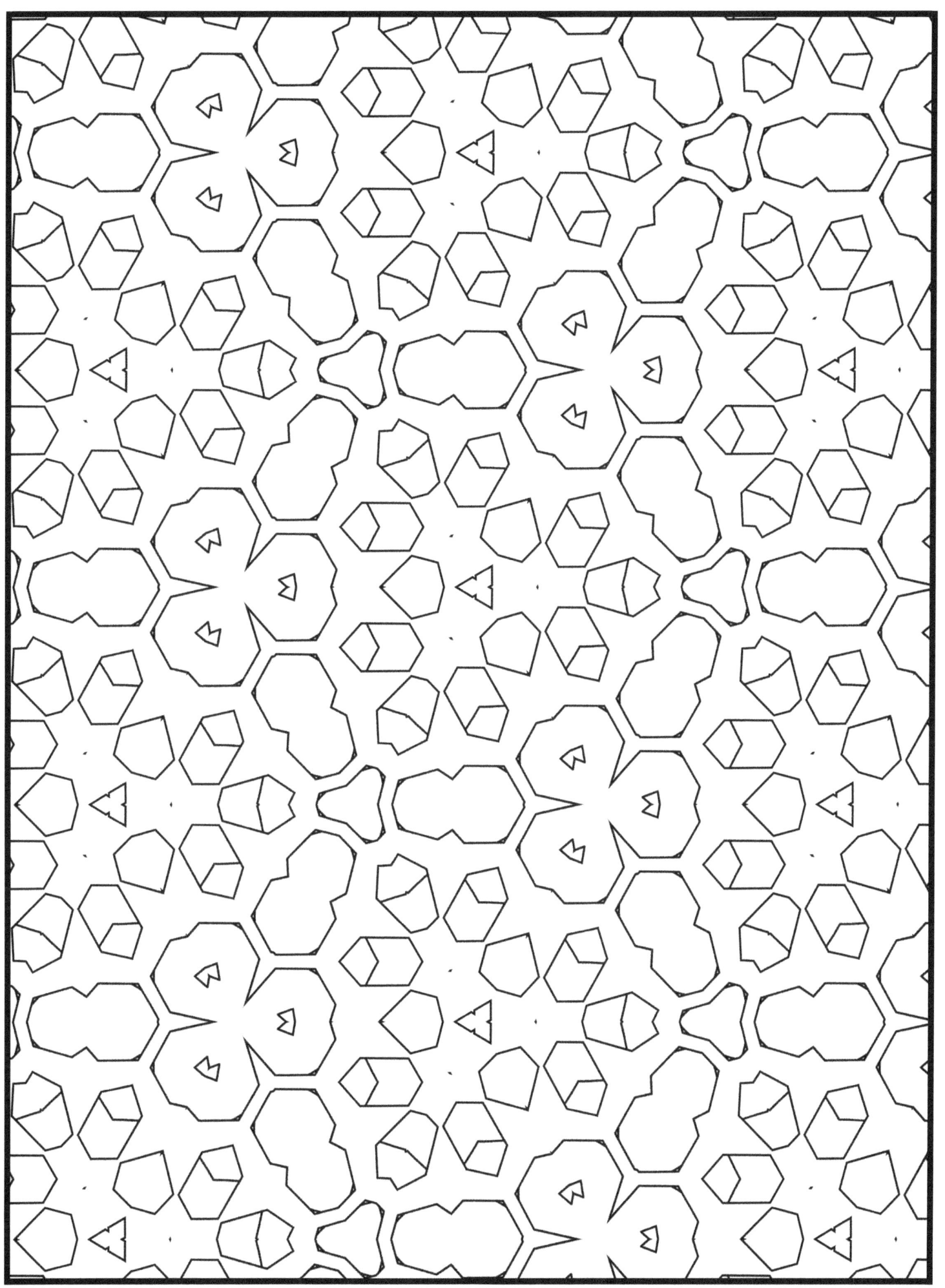

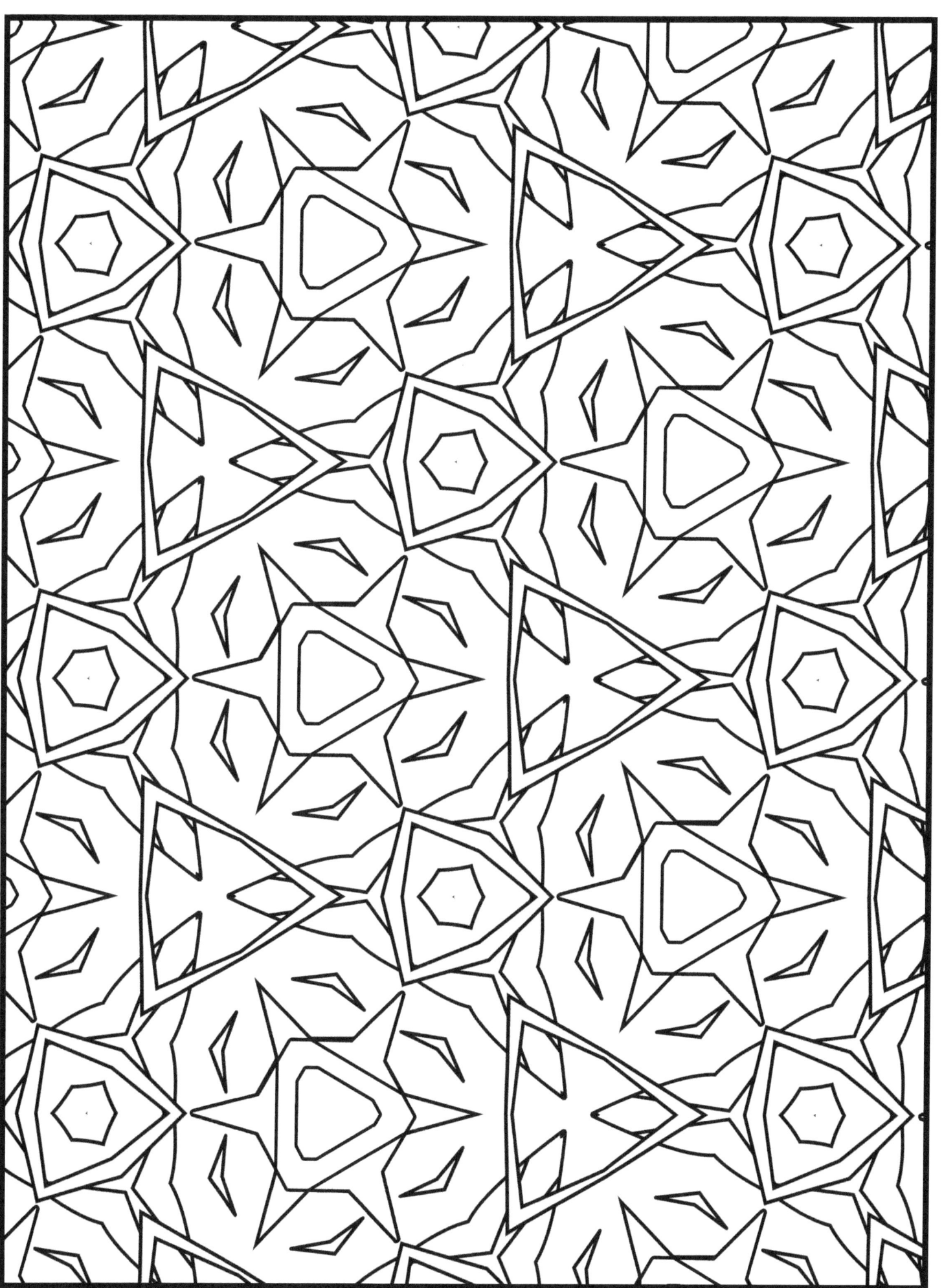

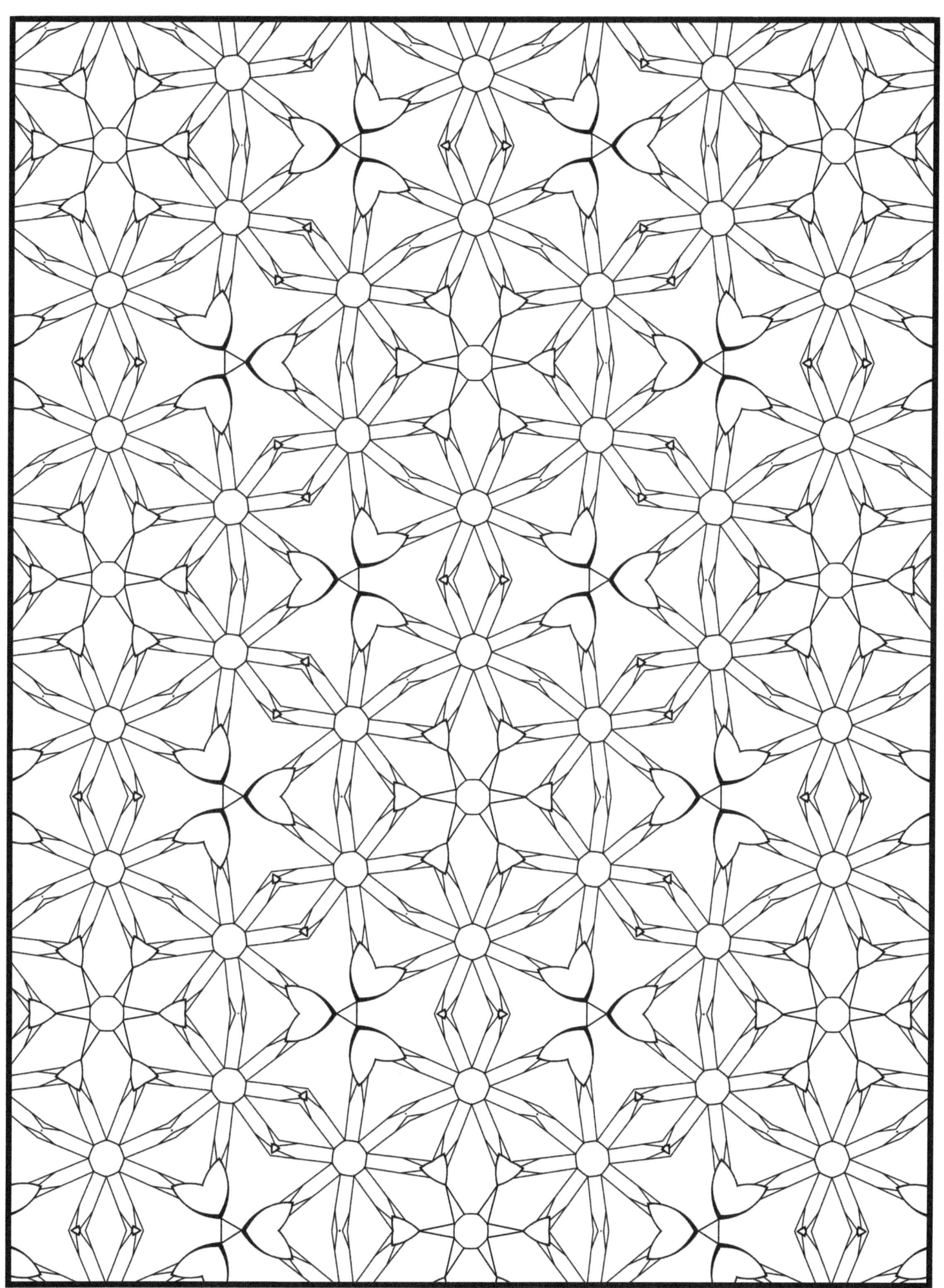

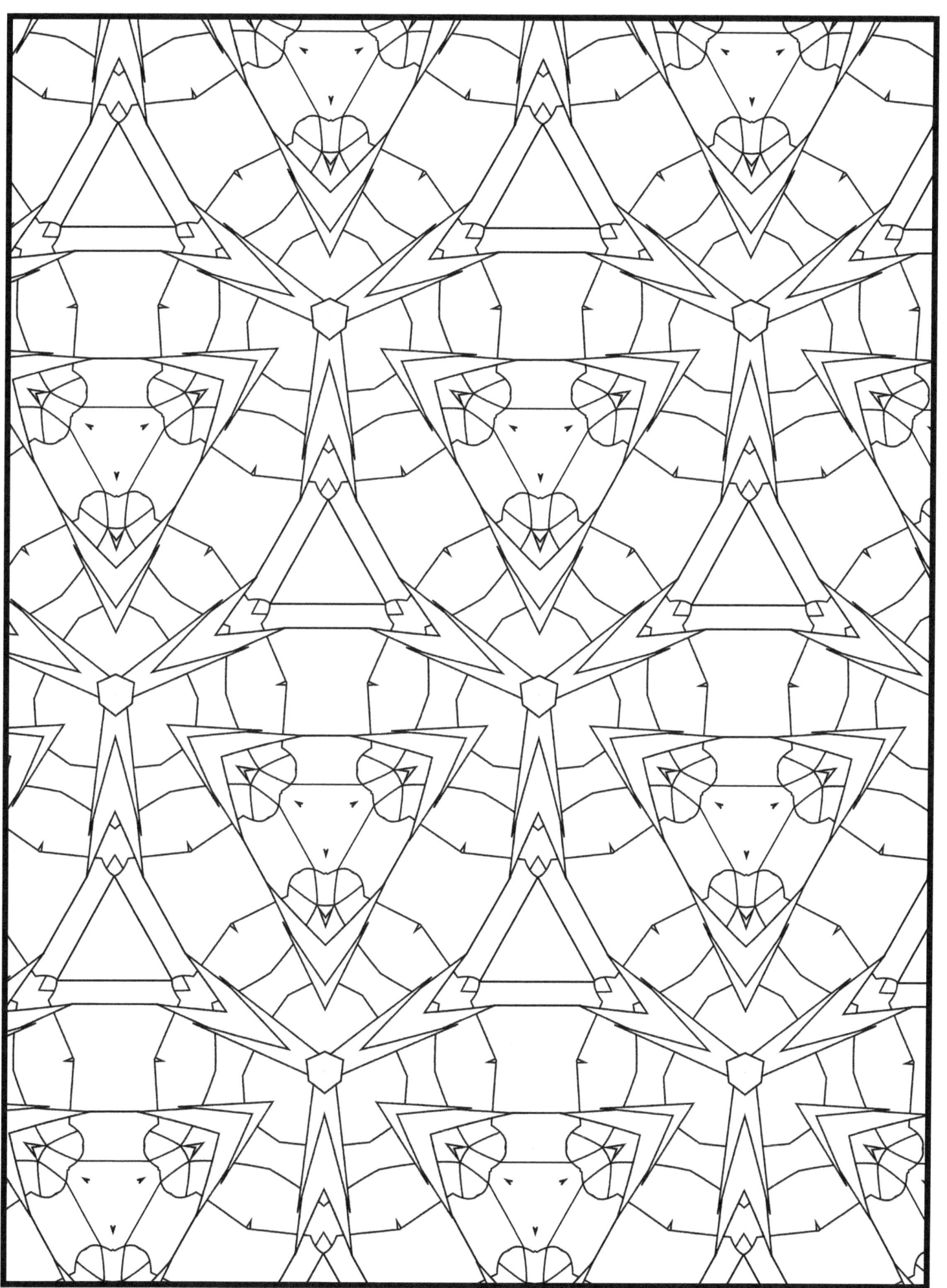

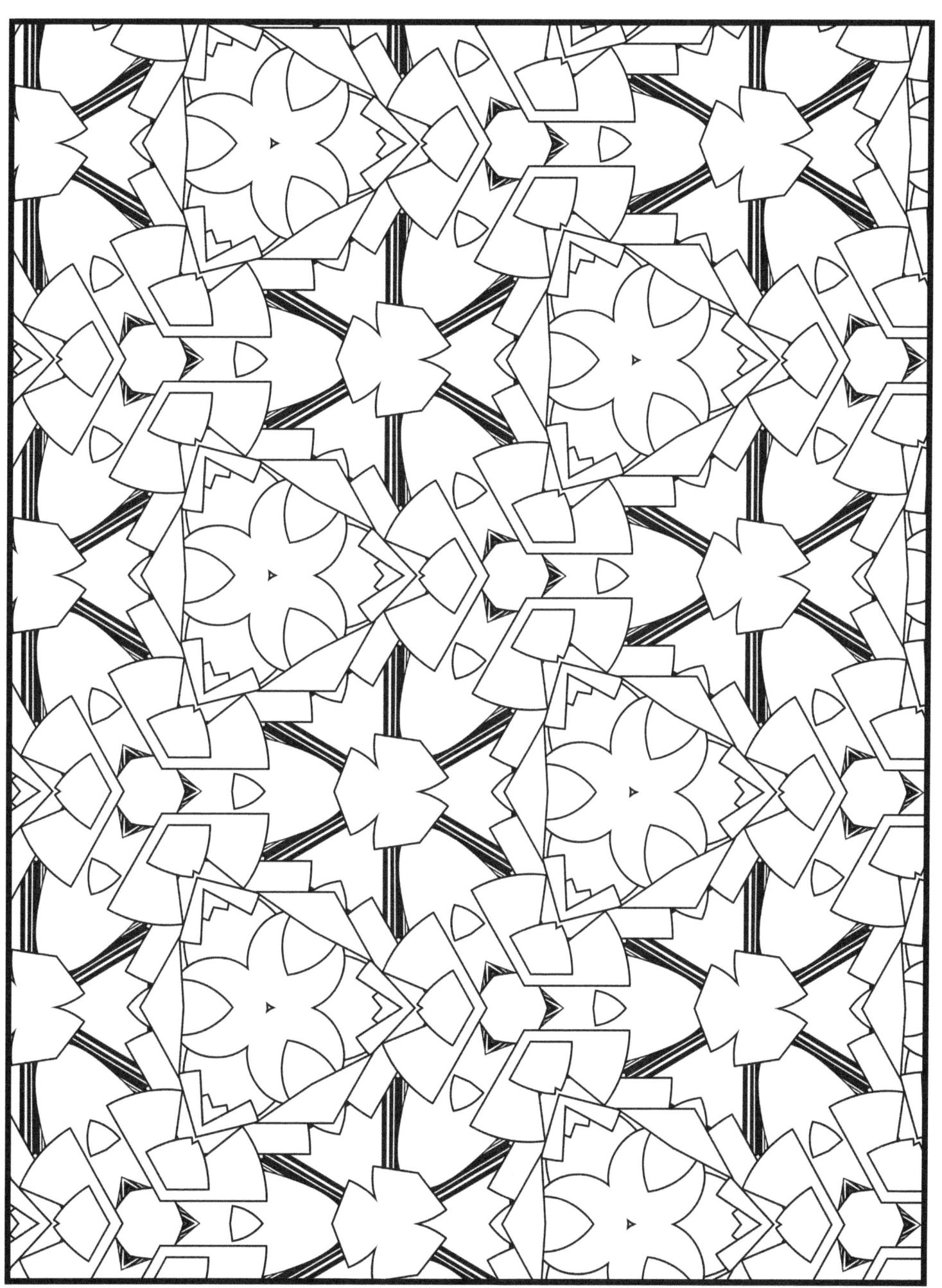

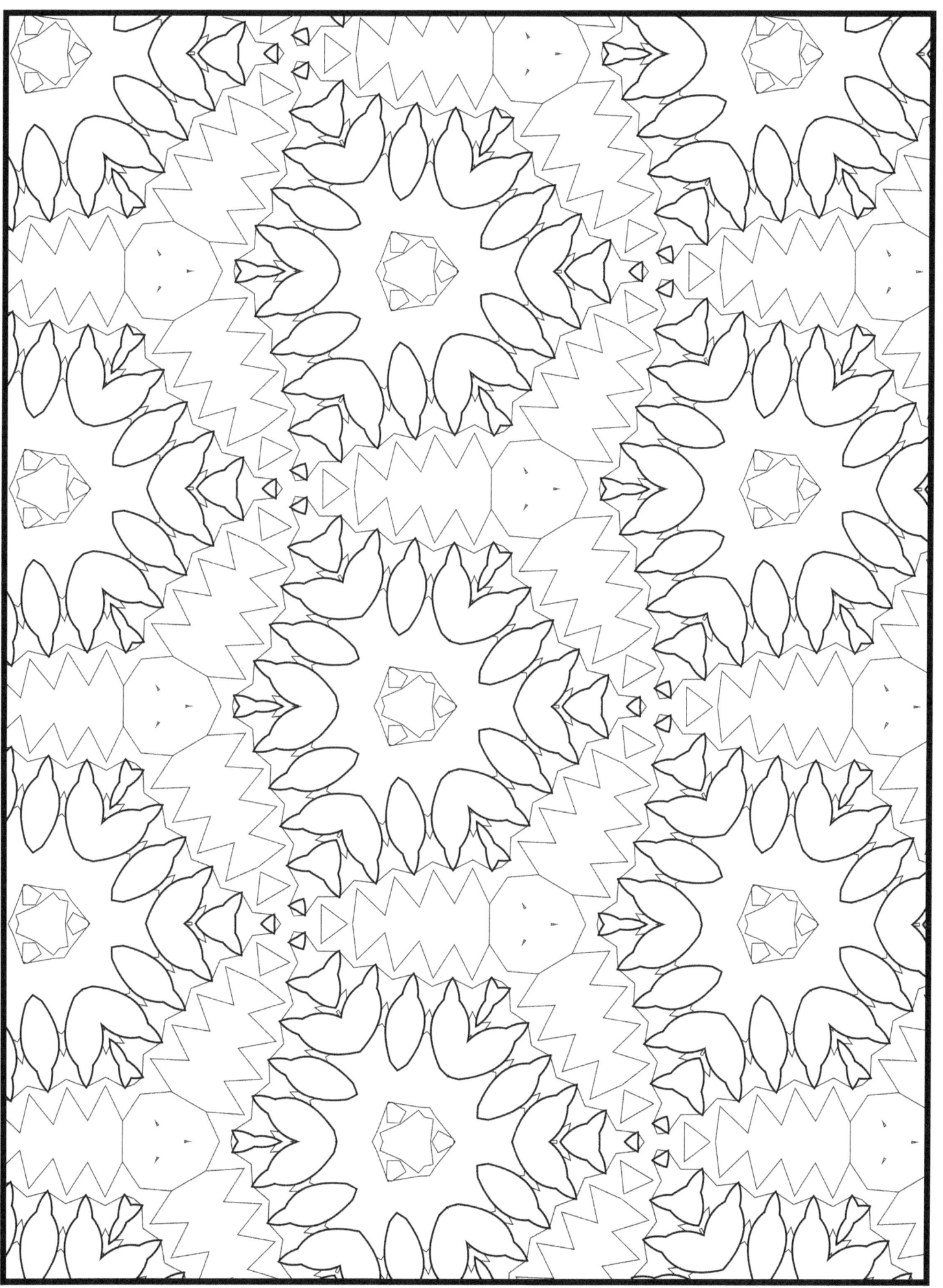

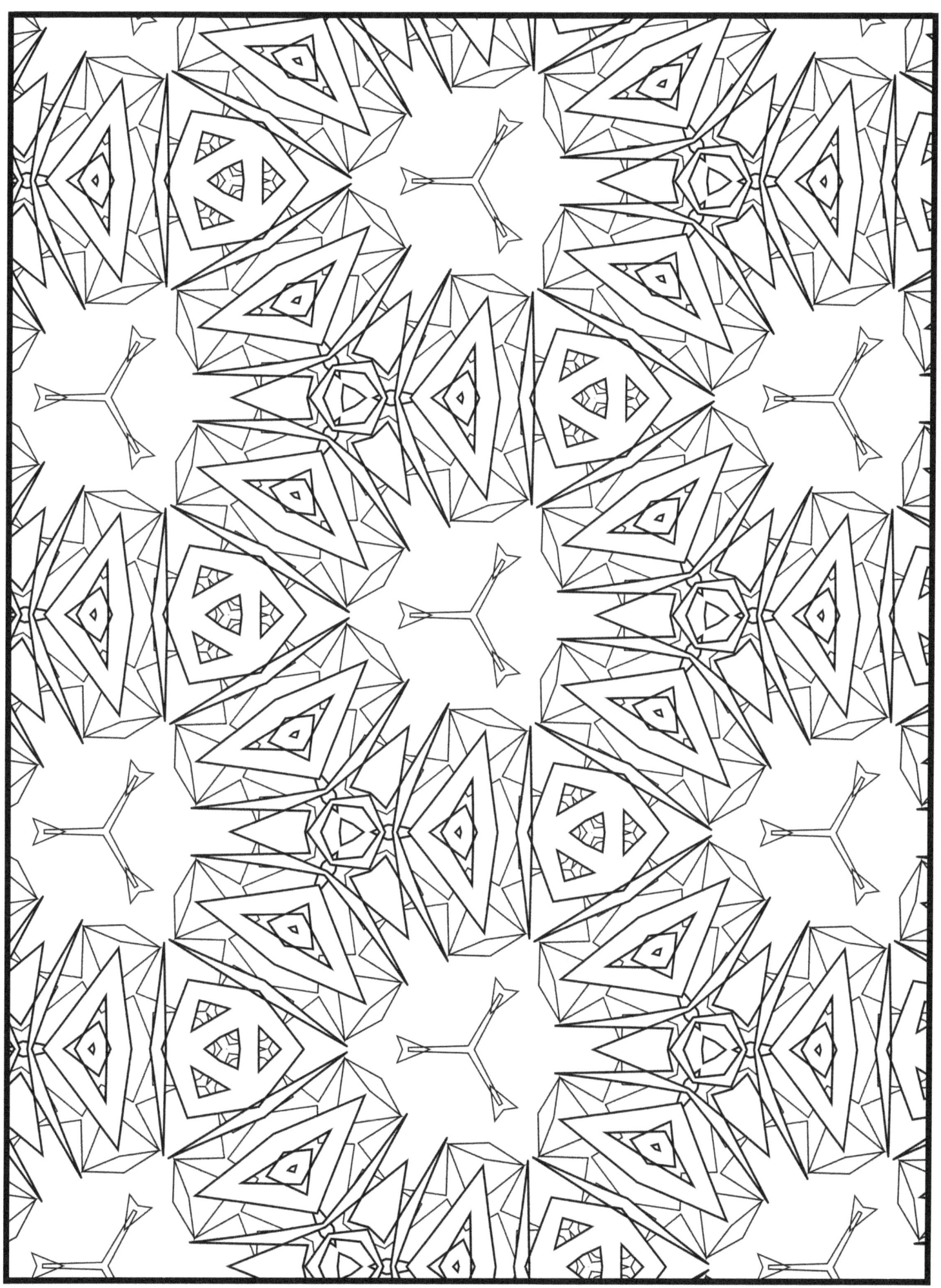

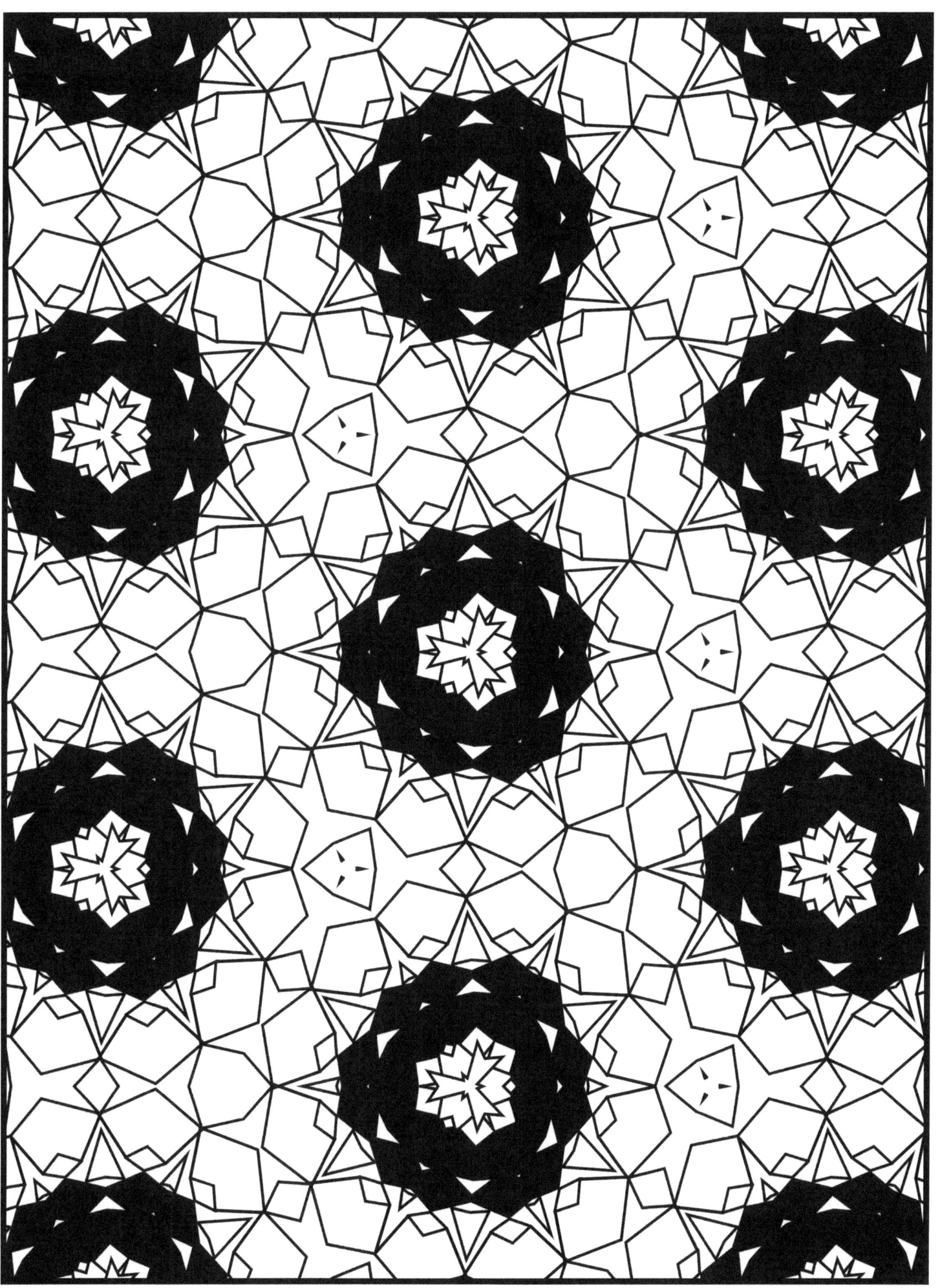

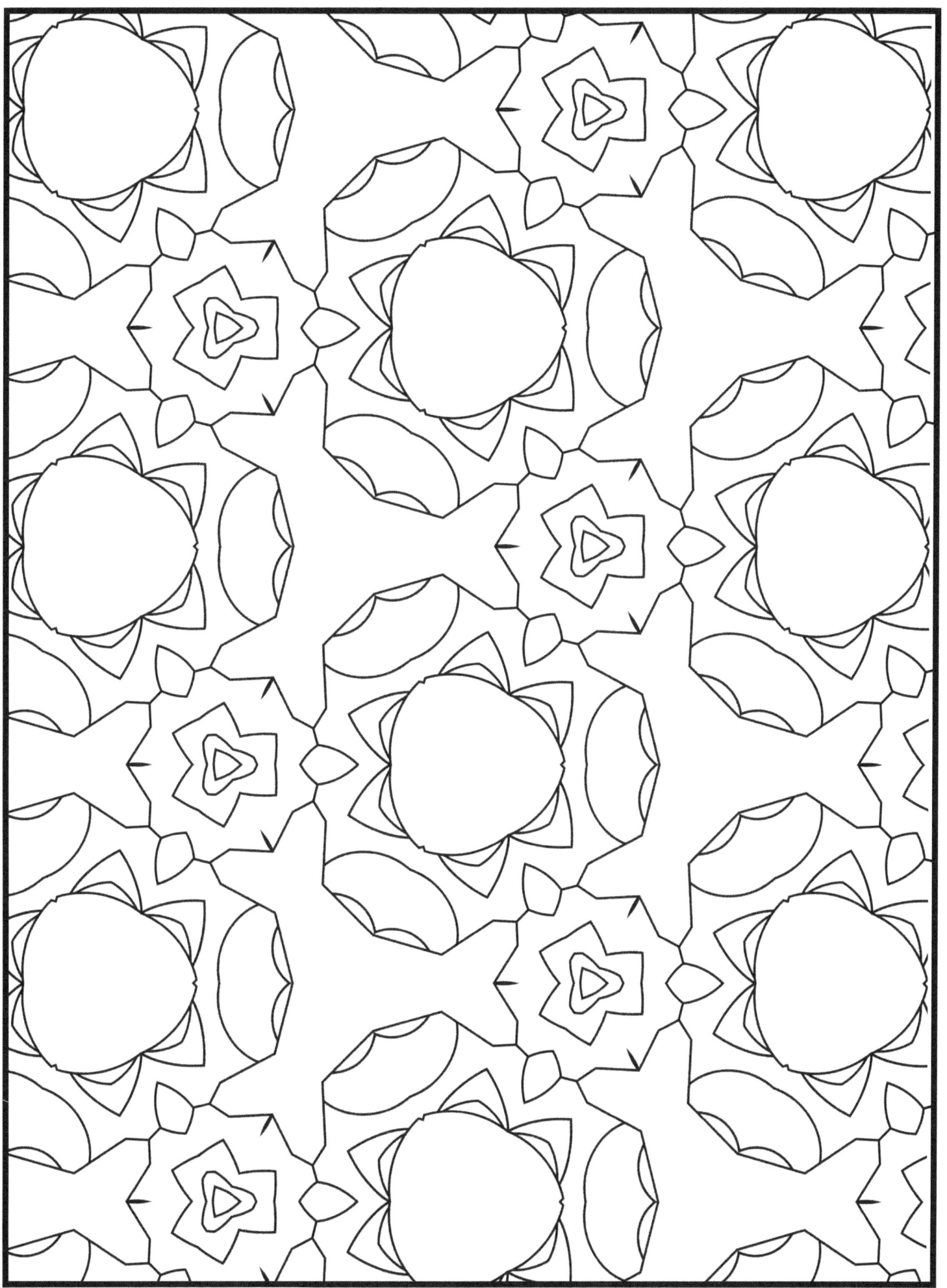

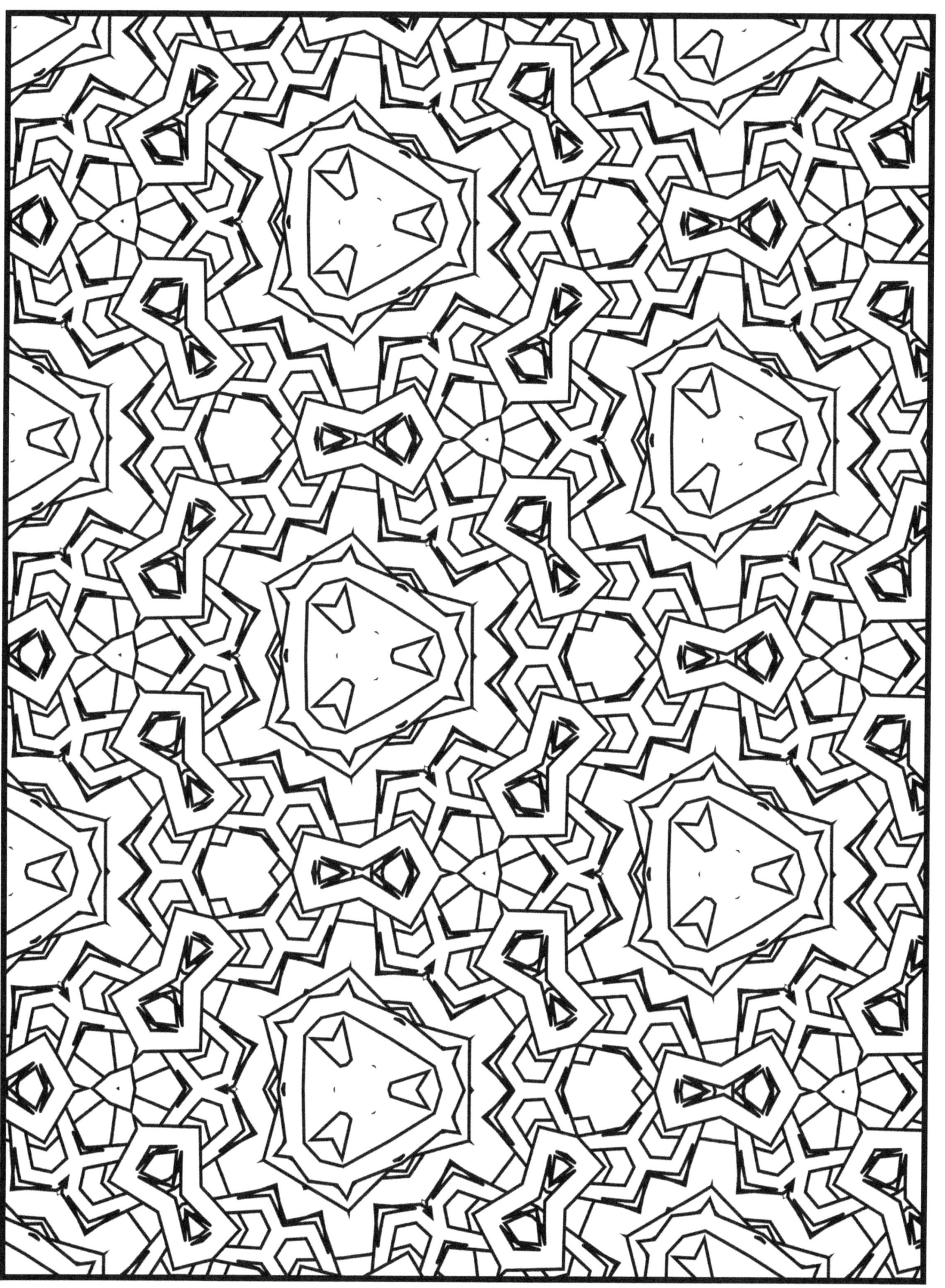

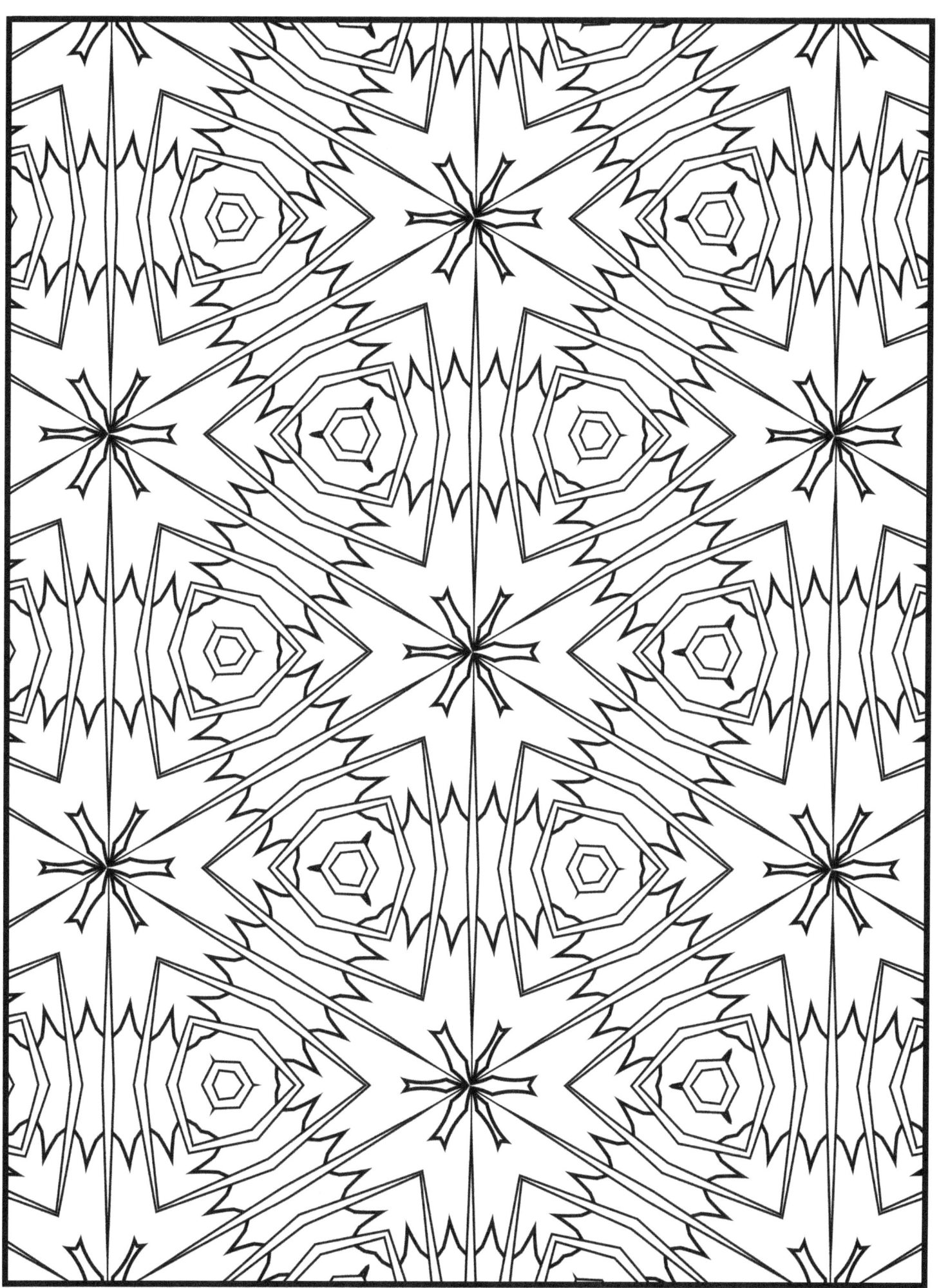

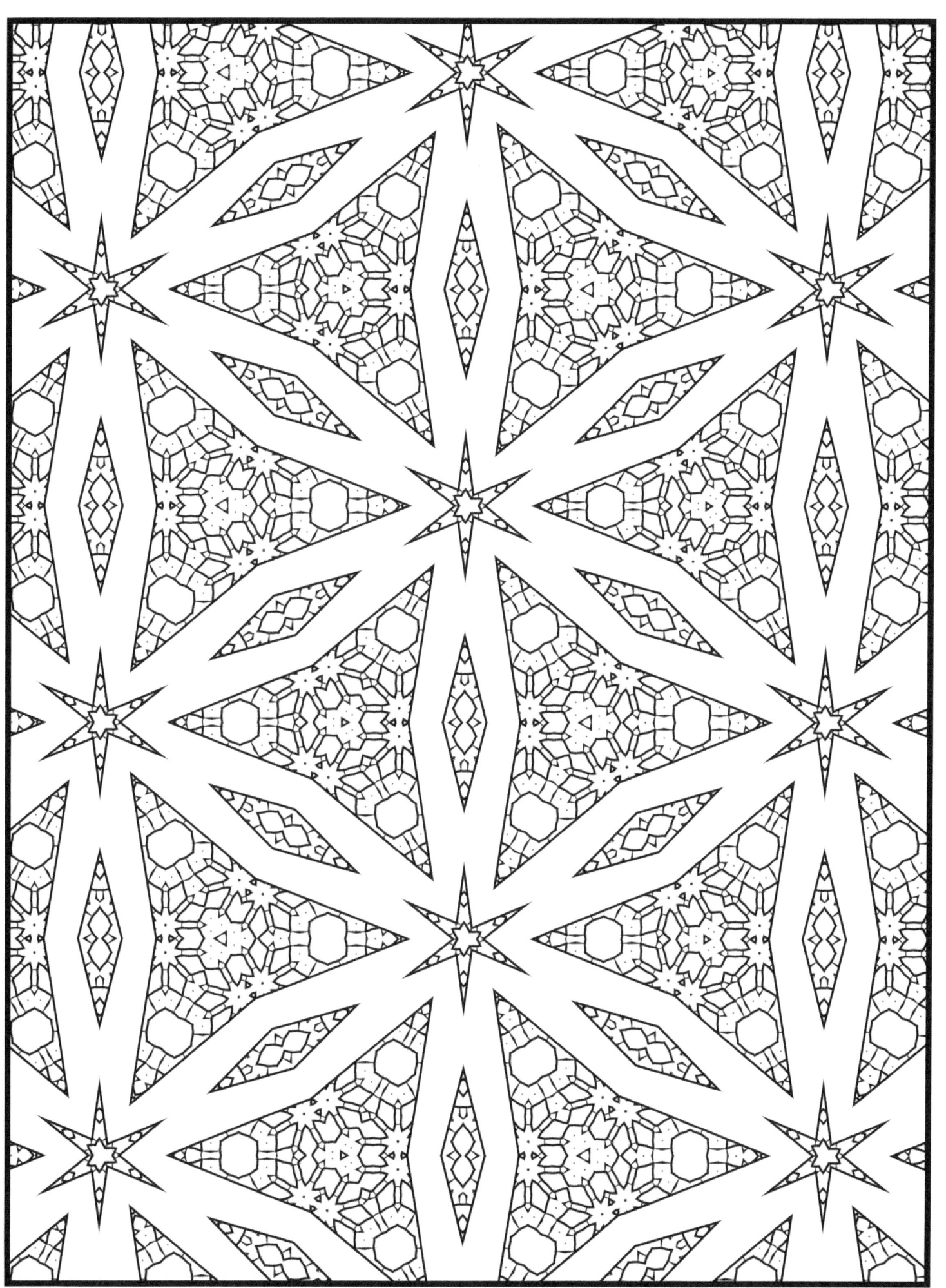

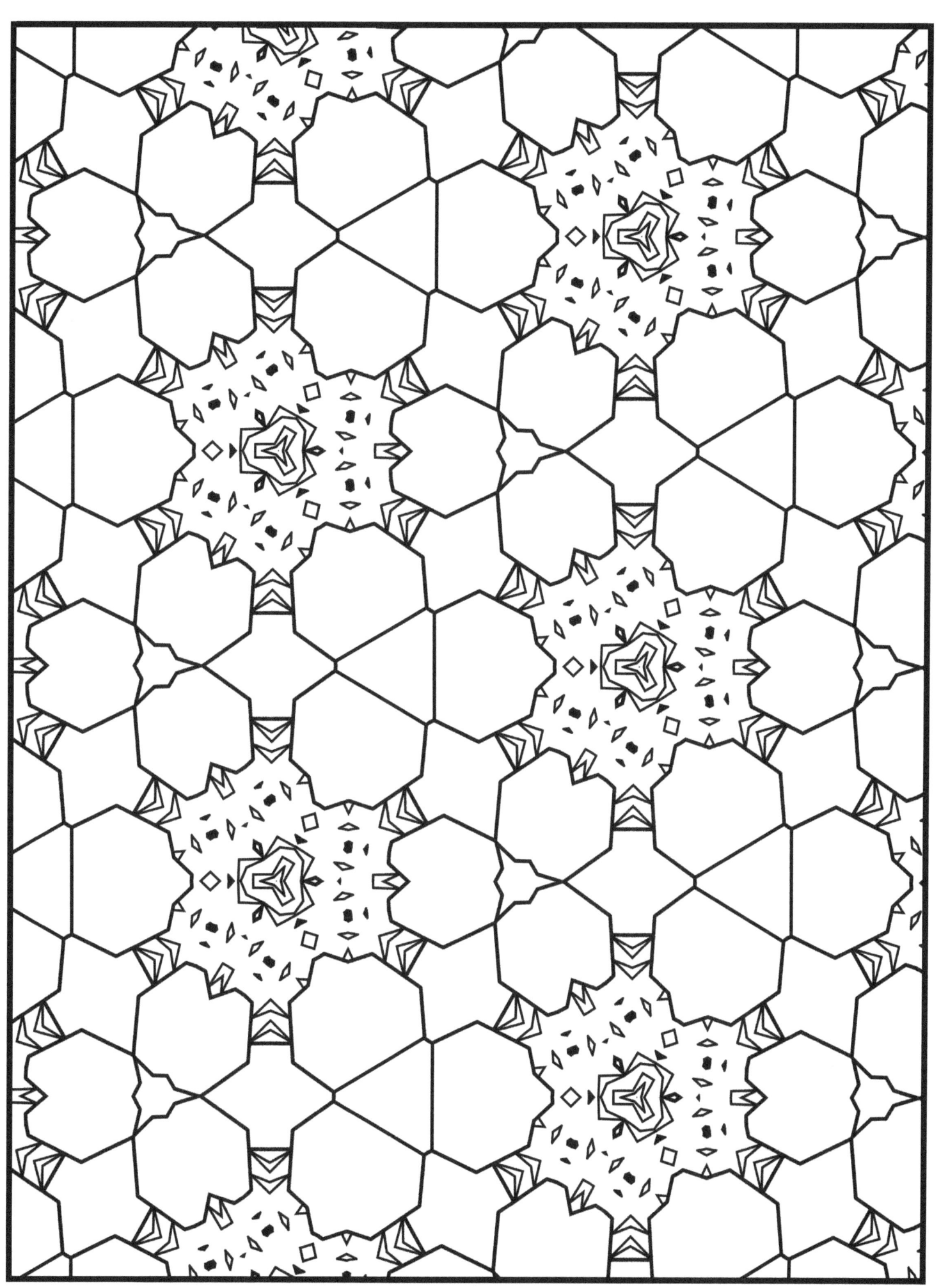

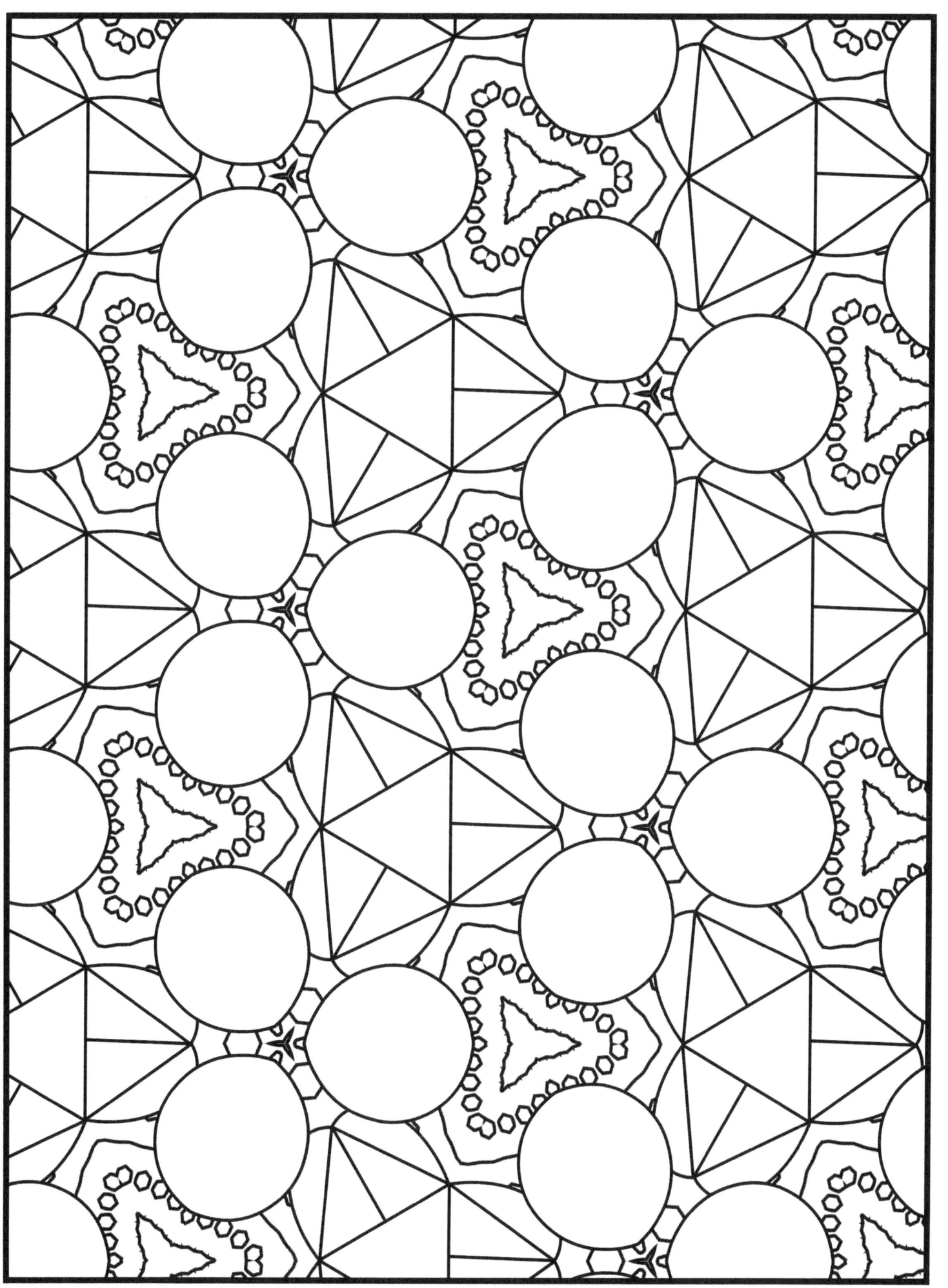

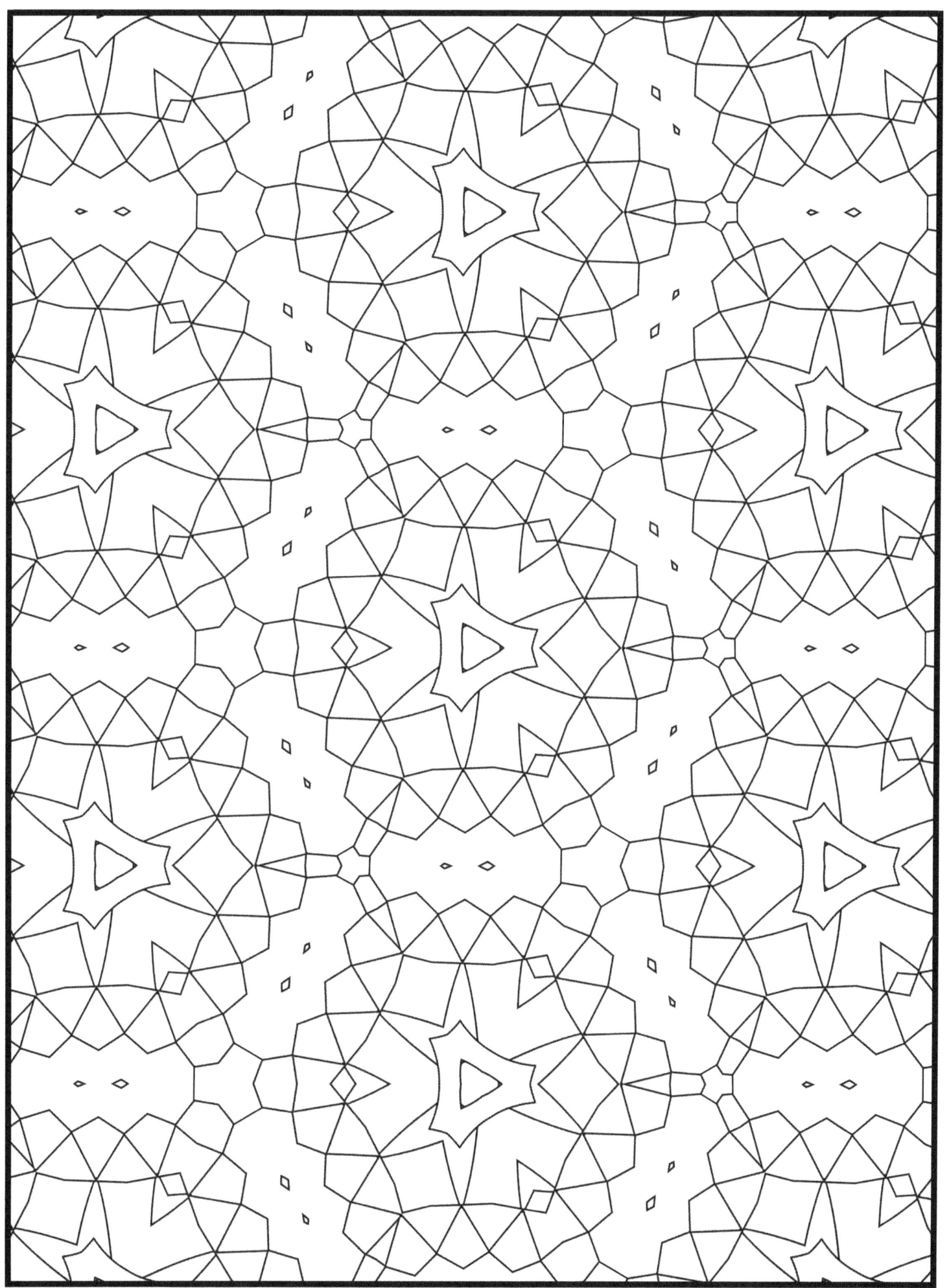

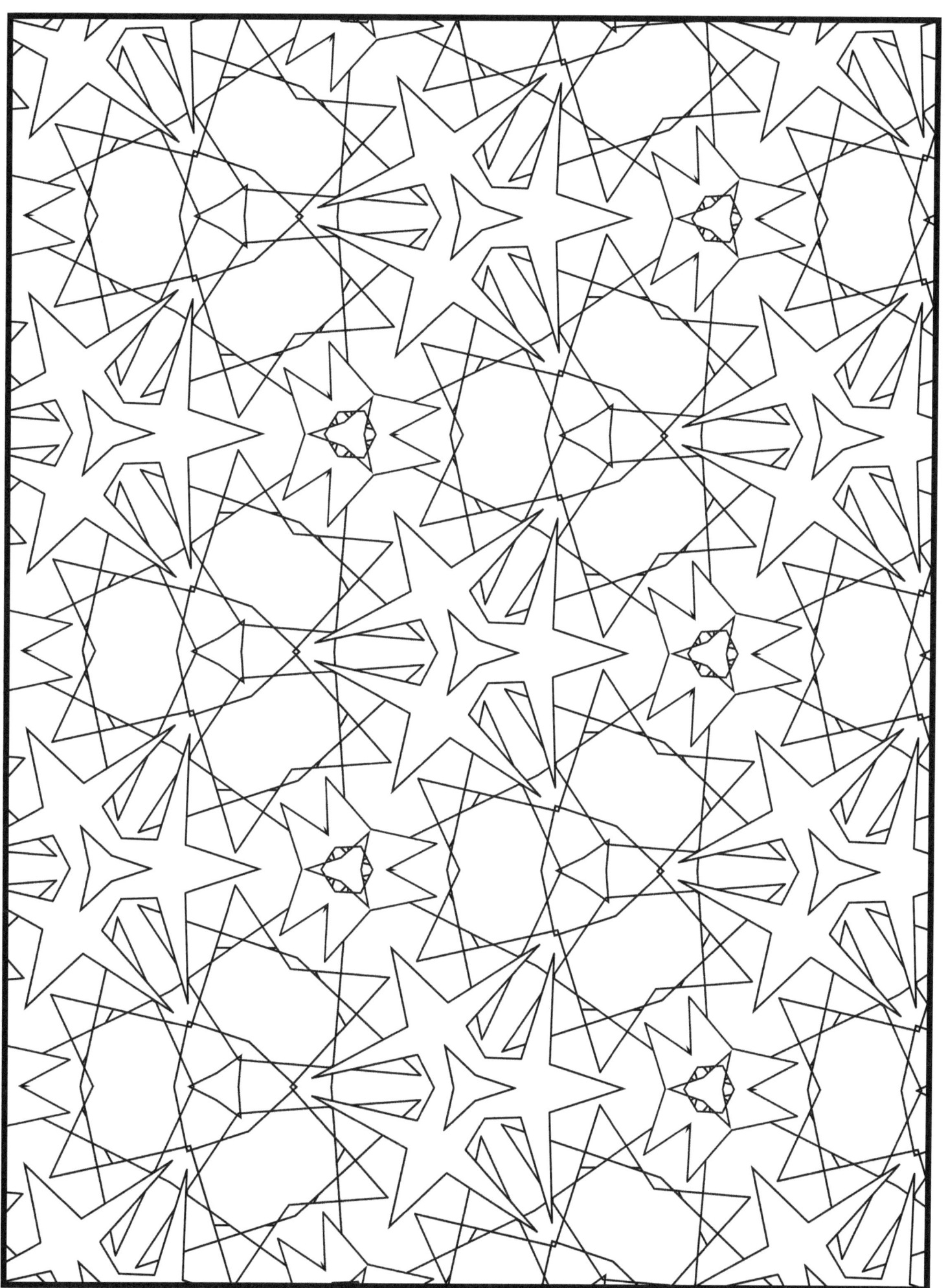

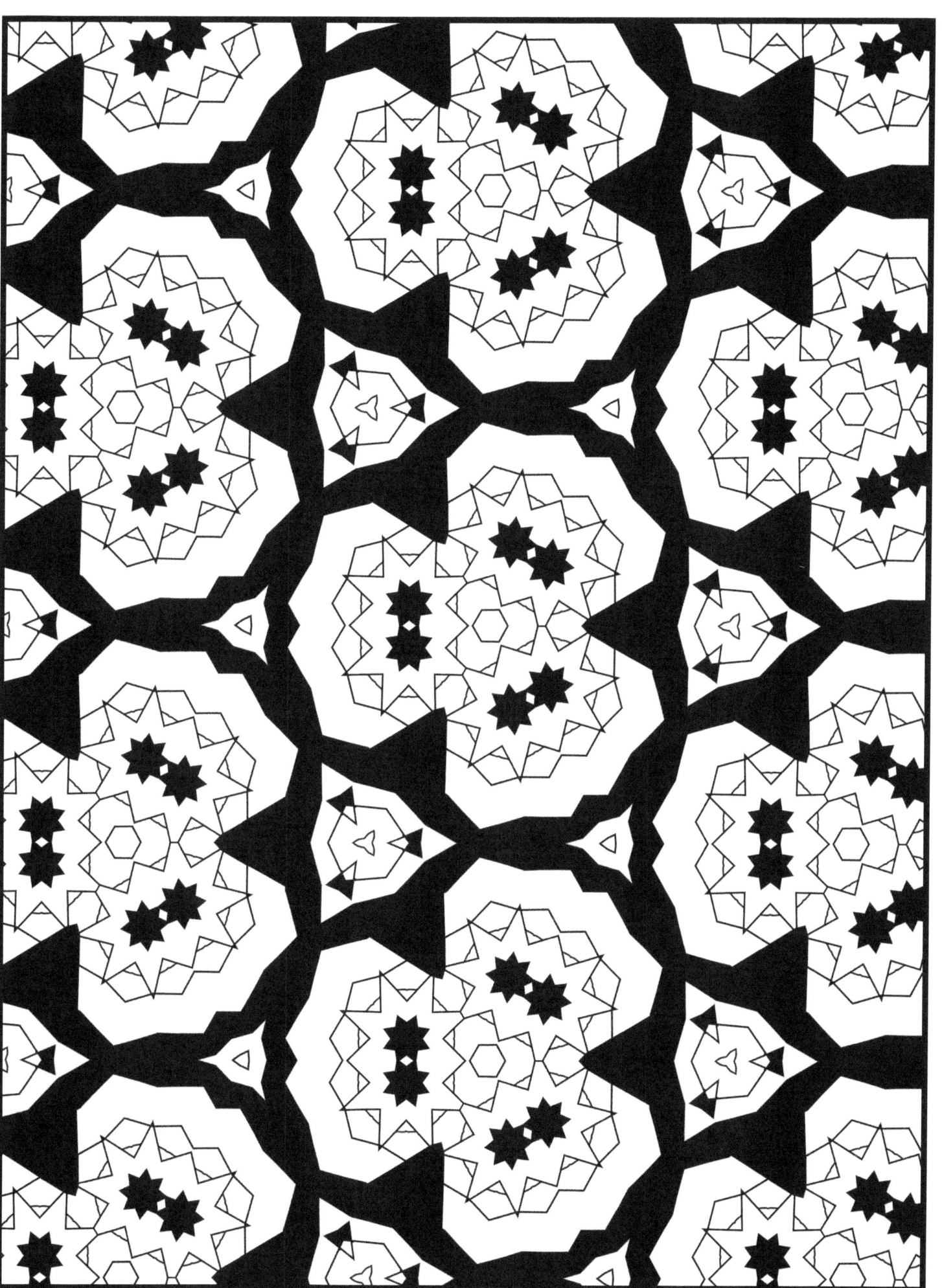

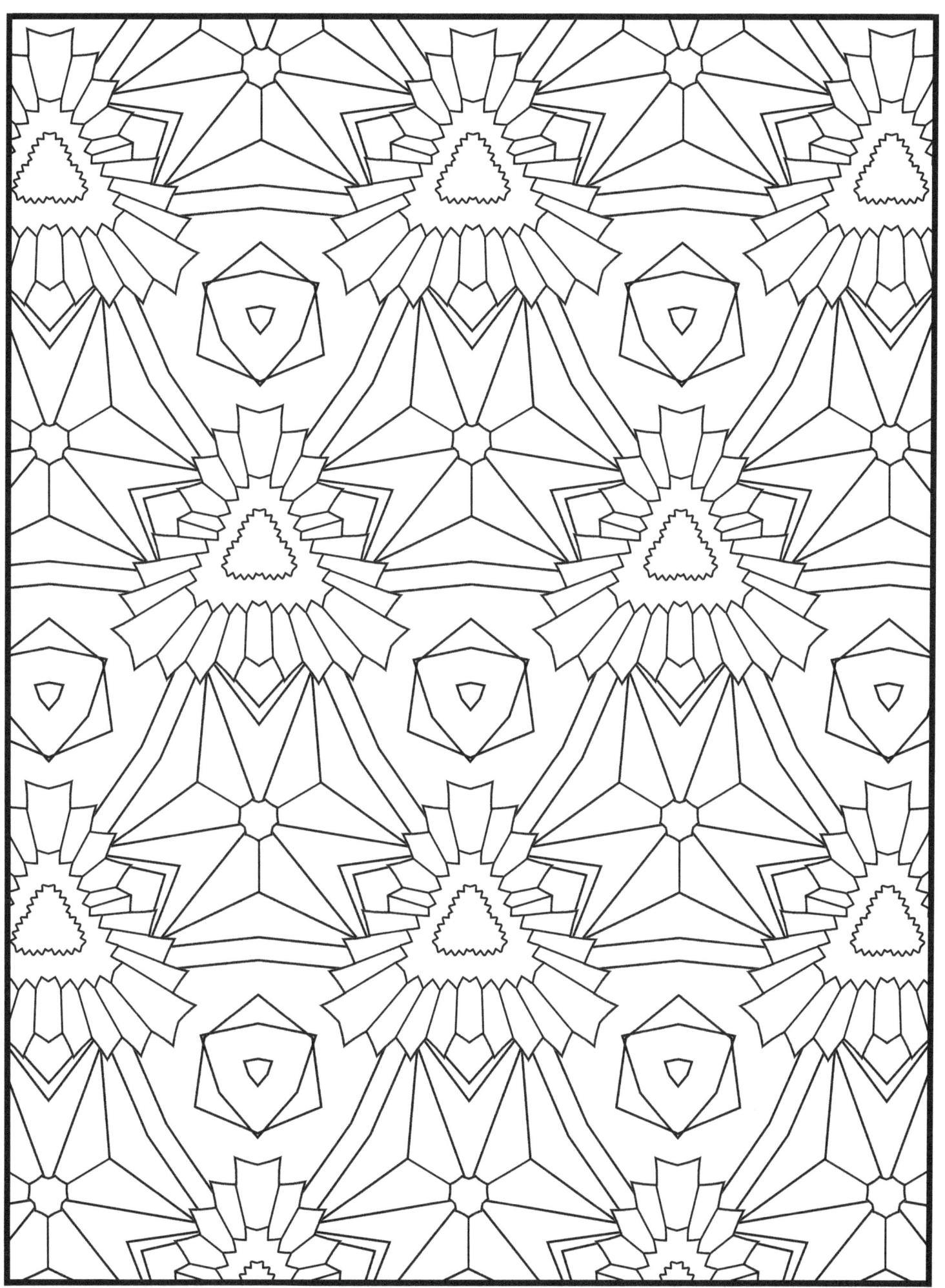

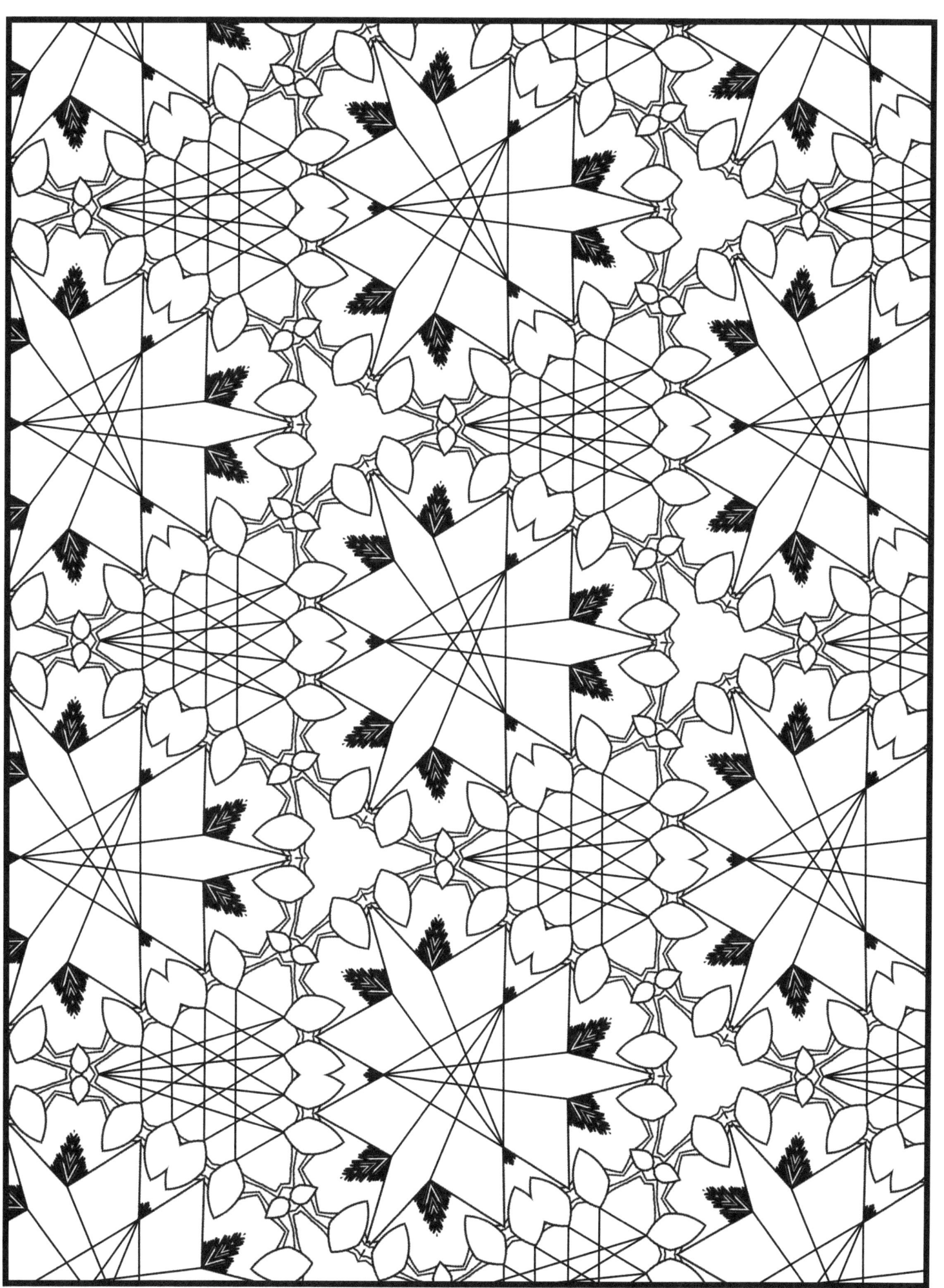

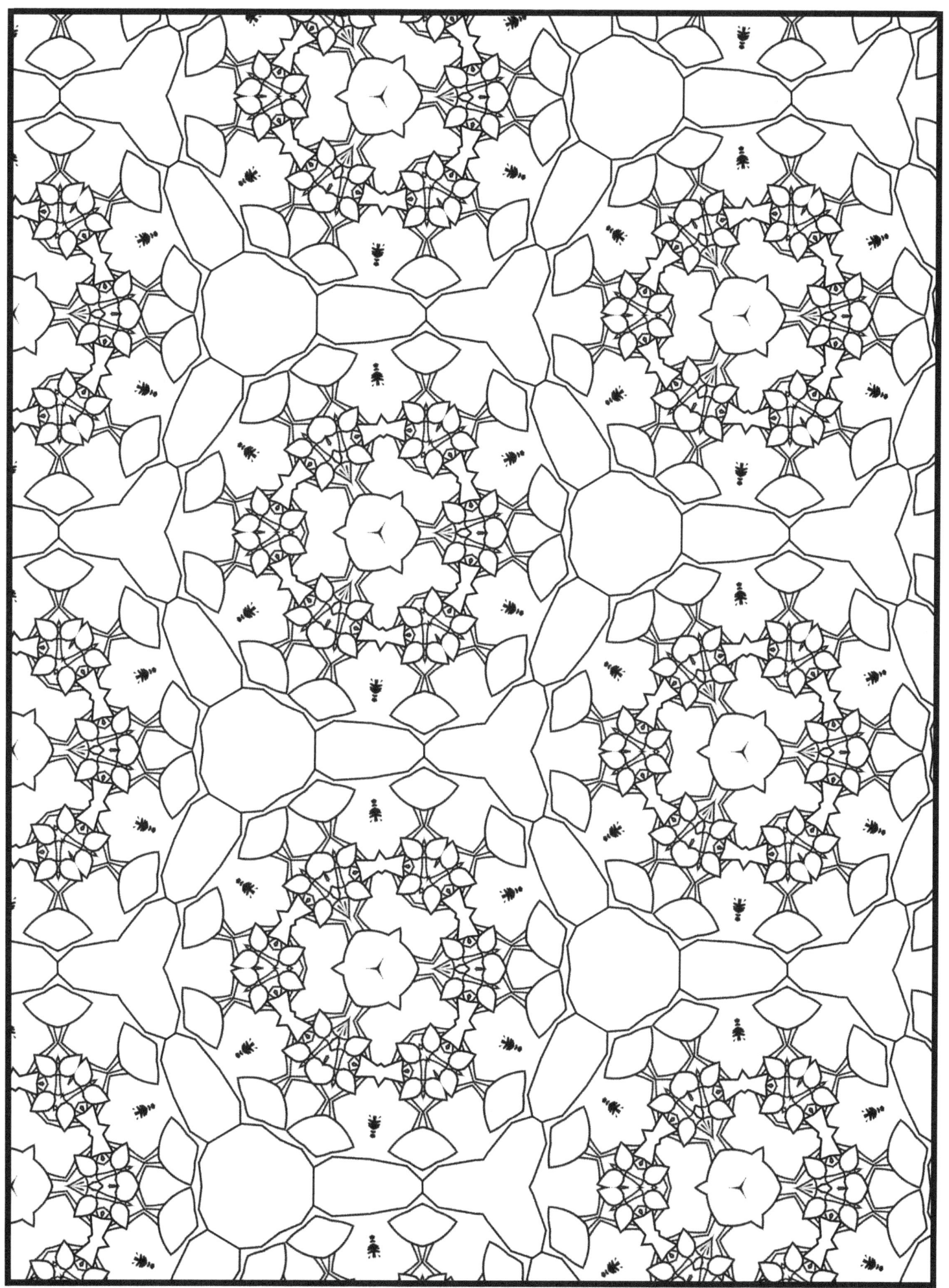

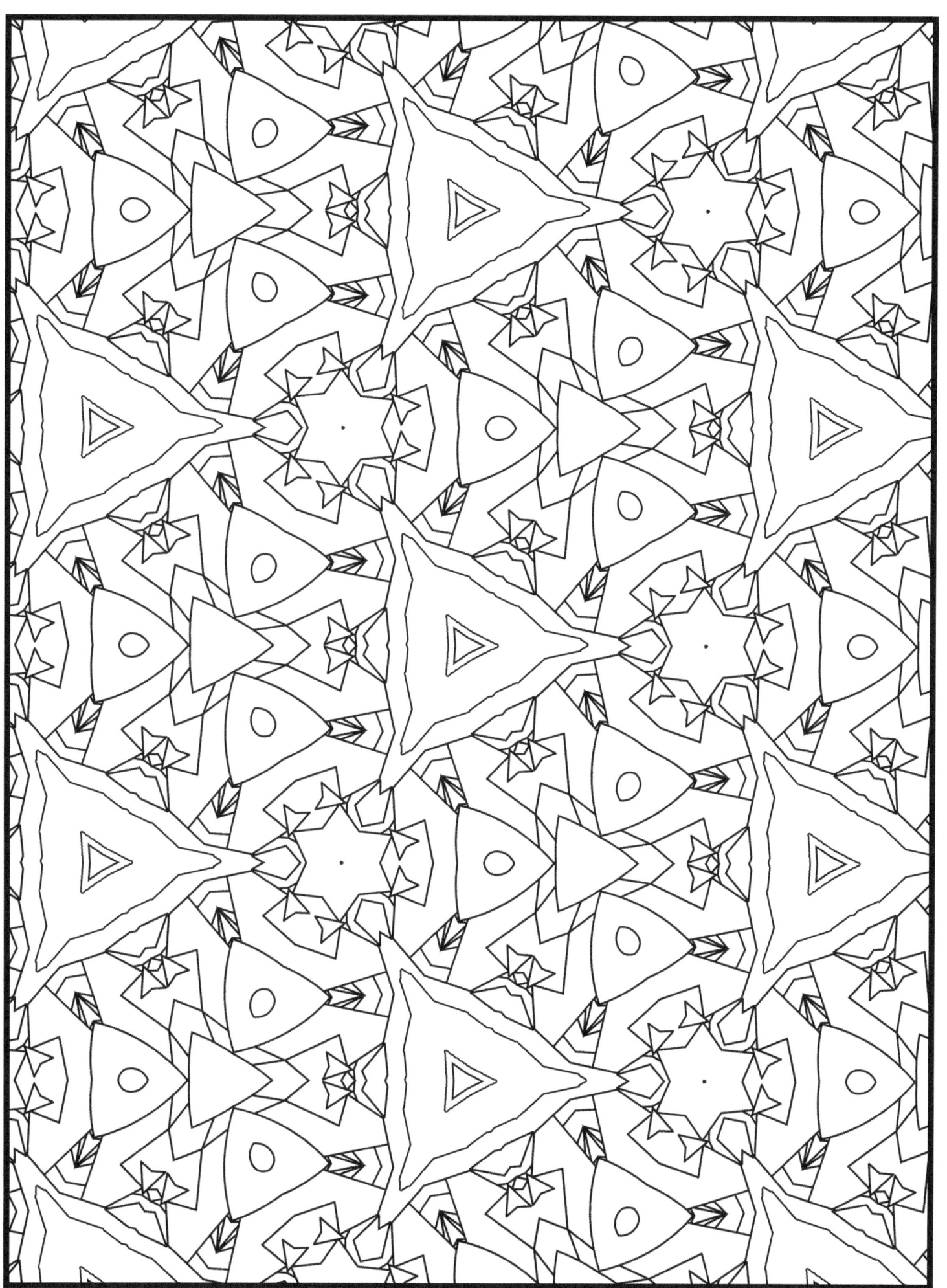

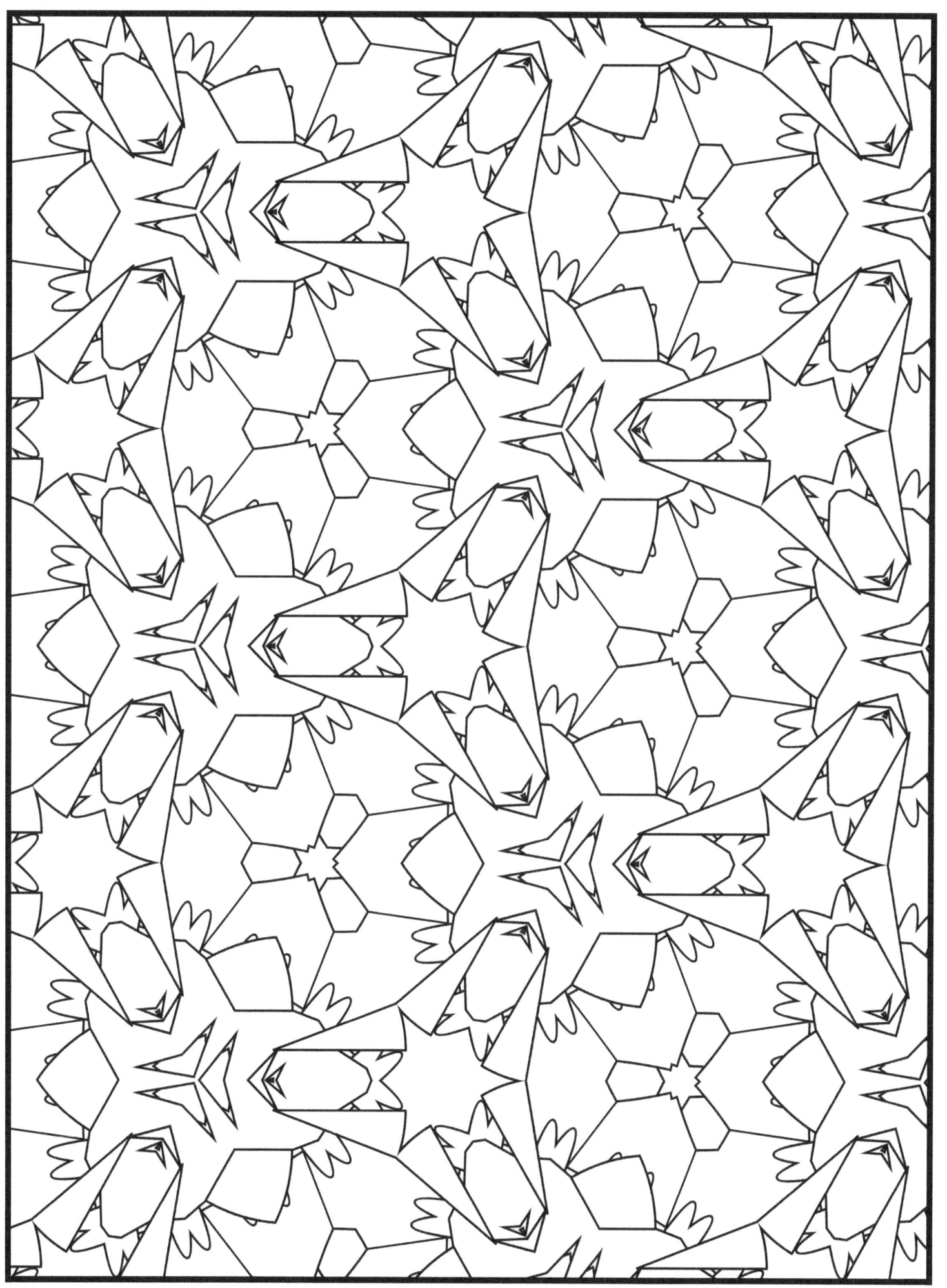

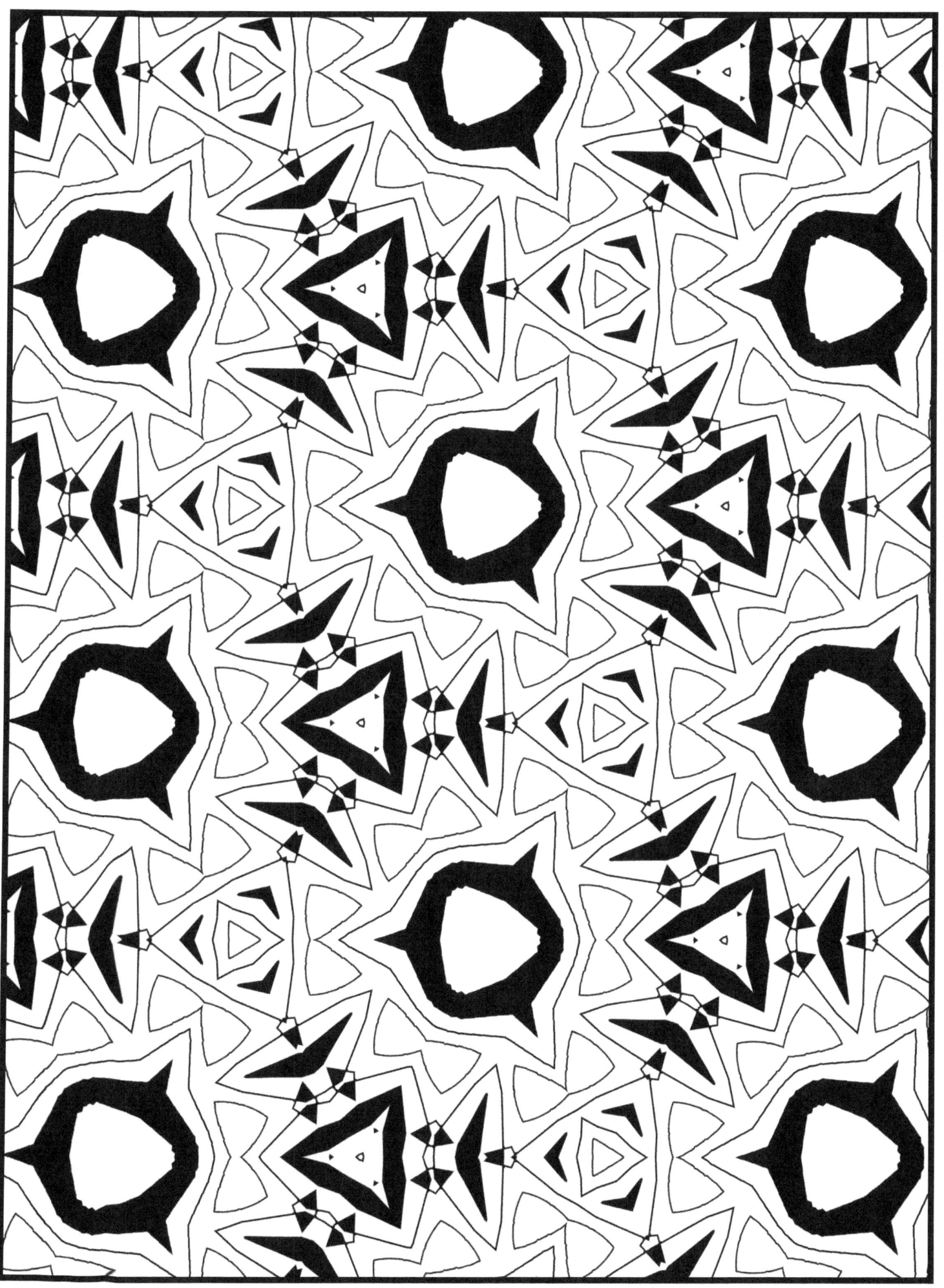